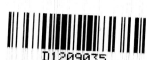

Christo and Jeanne-Claude

Christo and Jeanne-Claude
The Gates

(project for Central Park, New York City)

Christo and Jeanne-Claude

The Gates

Project for Central Park, New York City

A work in progress

Photographs by Wolfgang Volz

Picture Commentary by Jeanne-Claude and Jonathan Henery

An Exhibition Curated by Josy Kraft

HUGH LAUTER LEVIN ASSOCIATES, INC.

Topographic map of the Island of Manhattan, one of the five boroughs of New York City. North is on the right side of the map.

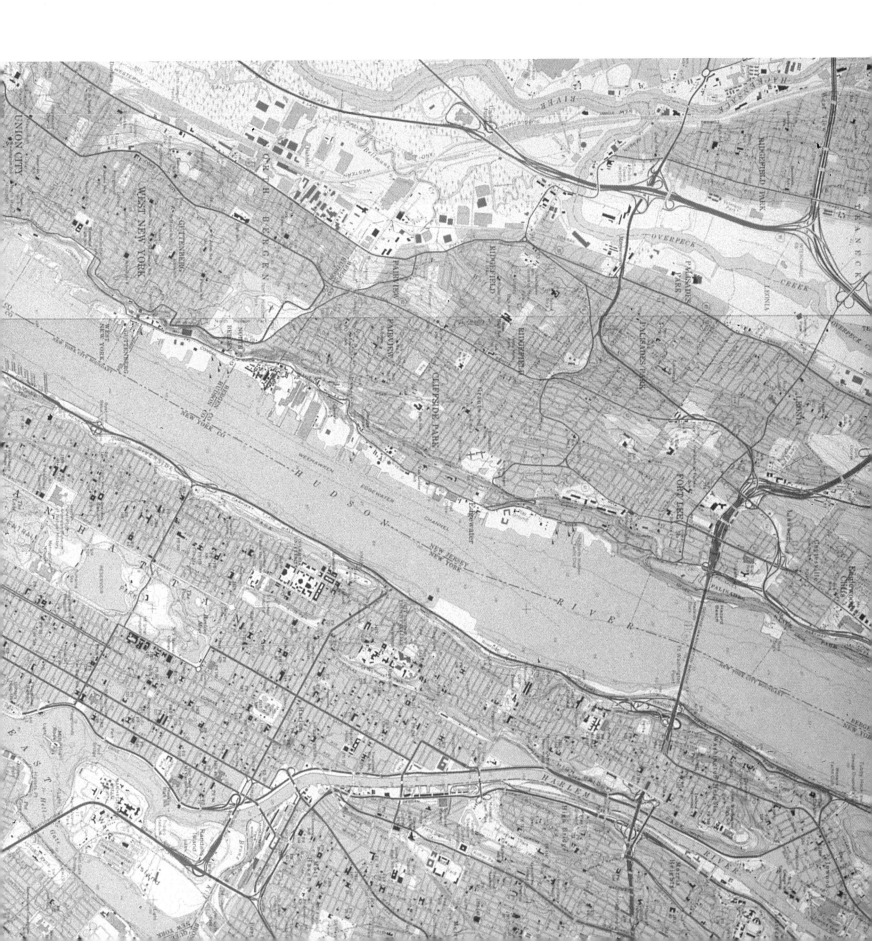

CHRISTO AND JEANNE-CLAUDE
THE GATES, PROJECT FOR CENTRAL PARK, NEW YORK

Frederick Law Olmsted, Sr. wrote that the park was "a single work of art… to which all parts were to be congruent and helpful." So too, *The Gates*. Because *The Gates* involve the entire topography of Central Park, they will be uniquely and equally shared by many different groups, thereby becoming a true "Public Work of Art," revealing the rich variety of the people of New York City.

The Gates will be 16 ft. high (4.8 m.) with a width varying from 8 to 28 ft. (2.4 m to 8.5 m.) following the edges of the walkways and perpendicular to the selected footpaths of Central Park. Free hanging fabric panels suspended from the horizontal top part of the gates will come down to approximately 7.1/2 ft. (2,29 ms) above ground. *The Gates* will be spaced at 10 to 15 ft. intervals (3 to 4.5 m.) allowing the synthetic woven fabric panels to wave horizontally towards the next gate.

The temporary work of art *The Gates* is scheduled to remain for 14 days during either the late fall, winter, or early spring (when the trees have no leaves) after which the 7.400 Gates spread on approximately 23 miles (37 kilometers) shall be removed and the materials will be recycled.

As Christo and Jeanne-Claude have always done for their previous projects, *The Gates* will be entirely financed by the artists through the sale of studies, preparatory drawings and collages, scale models, earlier works of the fifties and sixties, and original lithographs on other subjects.
The artists do not accept sponsorship of any kind.
Neither New York City nor the Park Administration shall bear any of the expenses for *The Gates*. *The Gates* will provide employment for thousands of New York City residents :
- Manufacturing and assembling of the gates structures.
- Installation workers
- Maintenance teams around the clock, in uniform and with radios
- Removal workers.
The 16 ft. high, 5 inch square (12,7 cm), extruded recyclable vinyl vertical poles, will be secured by narrow steel base weights positioned on paved surfaces, there will be no holes in the ground at all.
The on-site installation of the bases, by small teams, spread in the park will neither disturb the maintenance and management of the park nor theevery day use of the park by the people.
The off-side fabrication and assembly of the fabric panels and the gates structures will not be done in the park, but in local workshops, and factories.

A written contract shall be drafted between the Department of Parks and the artists.
The contract shall require the artists to provide :
- Personal and property liability insurance holding the Department of Parks and the city harmless.
- Removal Bond providing funds for complete removal.

- Full cooperation with the Department of Parks, the Central Park Conservancy, the New York Police Department, the NYC Arts Commission, the Landmarks Commission and the Community Boards.
- Clearance for the usual activities in the Park and access of Rangers, maintenance, clean-up, police and emergency vehicles.
- The artists shall pay all direct costs of the Park's supervision directly related to the project. Unlike twenty years ago, because of the experience of the NY Marathon and the gatherings on the Great Lawn, crowd control, security and emergency procedures are now well organized, and those additional expenses will be paid by the artists.
- Neither vegetation nor rock formations shall be disturbed.
The Gates will stay away from intersections, rocks, tree roots and low branches.
- Only vehicles of small size will be used and will be confined to the perimeter of existing walkways during installation and removal. The vehicles used for the installation will be no larger than those habitually used by the Parks Department. The people will continue to use the park as usual.
- Great precaution will be taken so as not to interfere with any of the wildlife patterns.
- The site shall be inspected by the Parks Department who will hold the Bond until satisfaction.

For those who will walk through *The Gates*, following the walkways, and staying away from the grass, *The Gates* will be a golden ceiling creating warm shadows. When seen from the buildings surrounding Central Park, *The Gates* will seem like a golden river appearing and disappearing through the bare branches of the trees while highlighting the shape of the footpaths.

The 14 day duration work of art, free to all, will be a long-to-be-remembered joyous experience for every New Yorker, as a democratic expression that Olmsted invoked when he conceived a "central" park. By up-lifting and framing the unnoticed space above the walkways, the luminous fabric of *The Gates* will underline the organic design of the park, in contrast to the geometric grid pattern of the city blocks of Manhattan, and will harmonize with the beauty of Central Park.

The Gates, Project for Central Park, New York.
Collage 1980.
71 x 56 cm (28 x 22").
Pencil, fabric, photograph by Wolfgang Volz, pastel, charcoal, wax crayon and fabric sample.

Central Park,

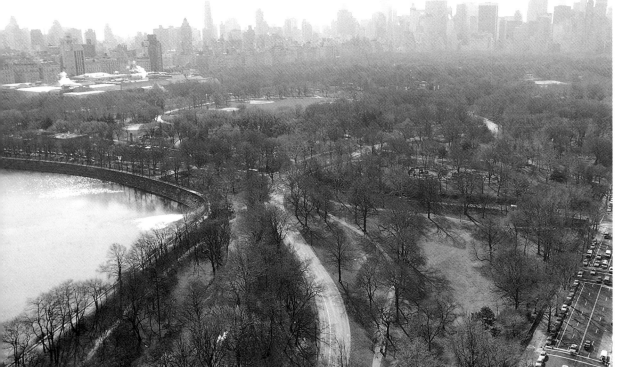

Above : The orange lines on the map indicate the location of the 7,400 Gates on the 37 kilometers (23 miles) of walkways which will be framed by the Gates.
North is on the right side.

Central Park in winter, when the trees have no leaves, seen from a 29th. floor on Central Park West (on the right).
On the left : the Reservoir and the Metropolitan Museum on Fifth Avenue.
At the top center : Central Park South.

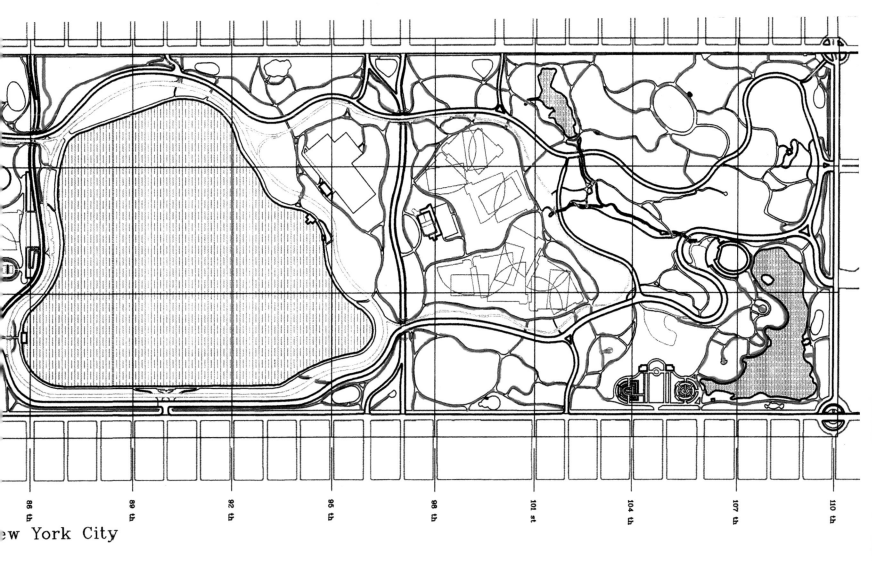

86 th 89 th 92 th 95 th 98 th 101 st 104 th 107 th 110 th

Walkways near East 66th Street.

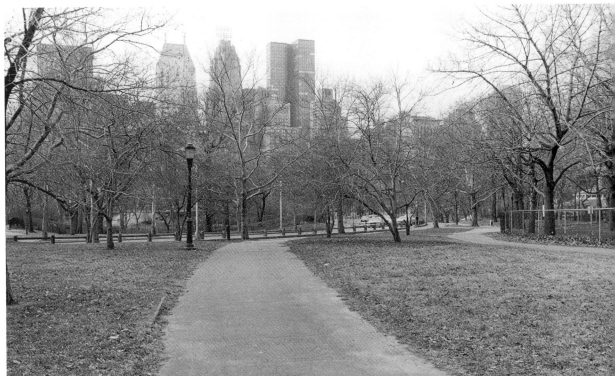

Next spread : View from the Sheep Meadow looking towards Central Park South at 59th Street.

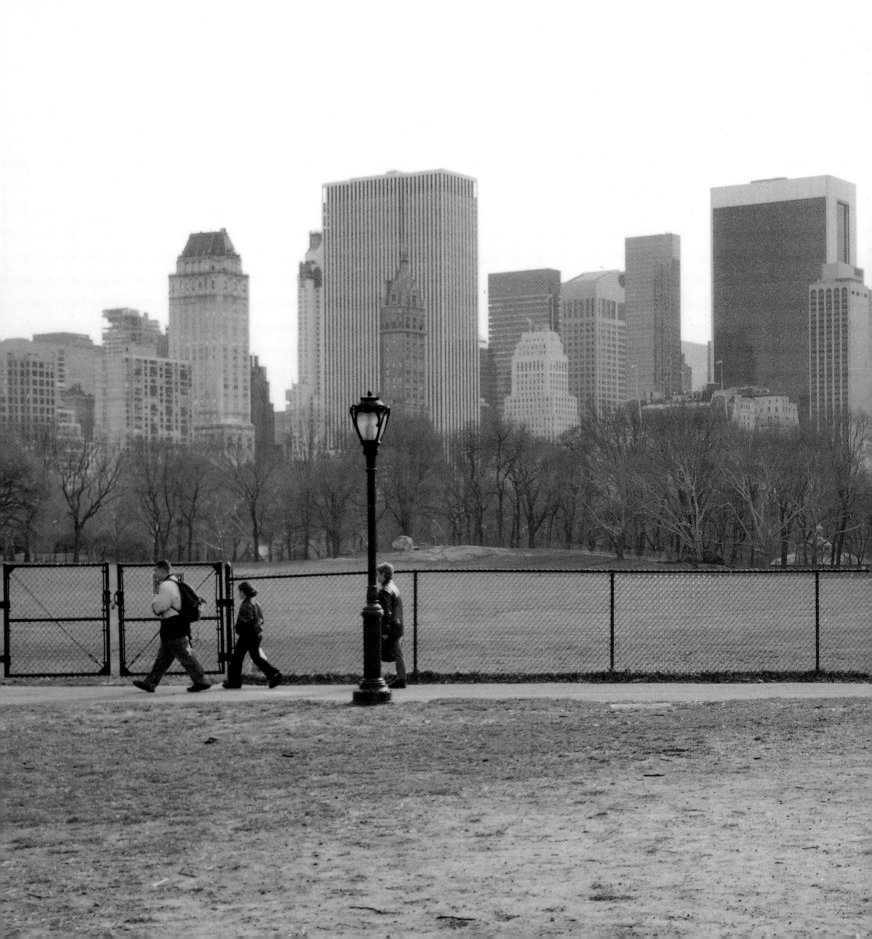

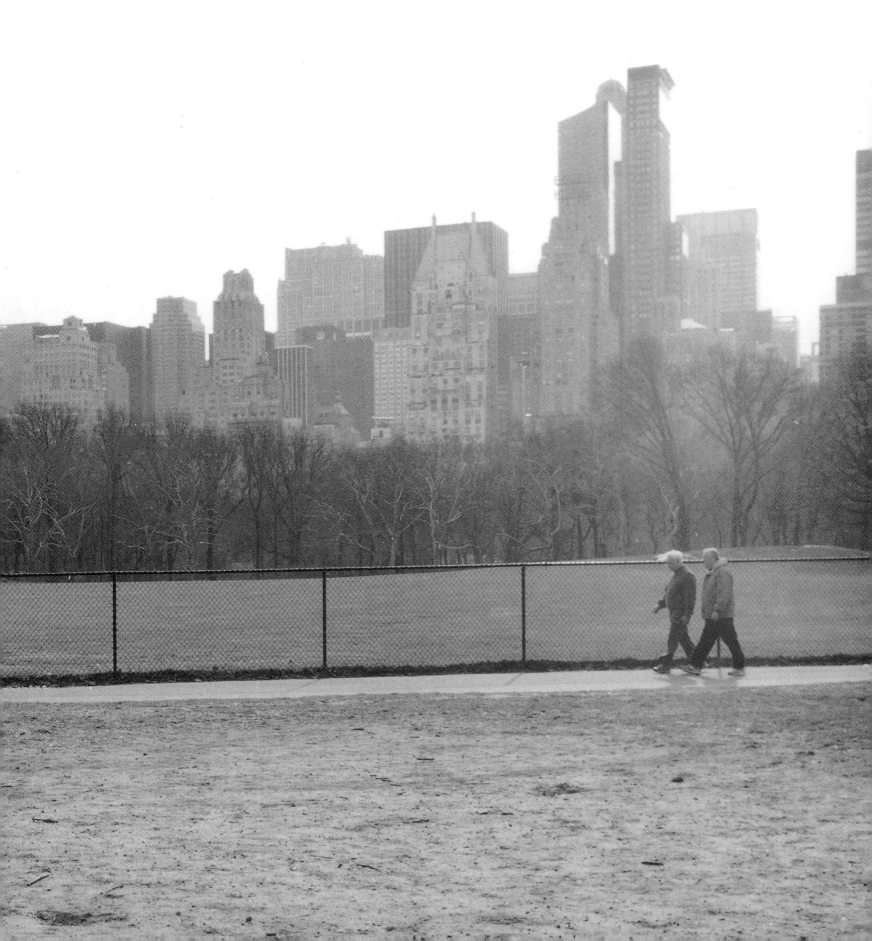

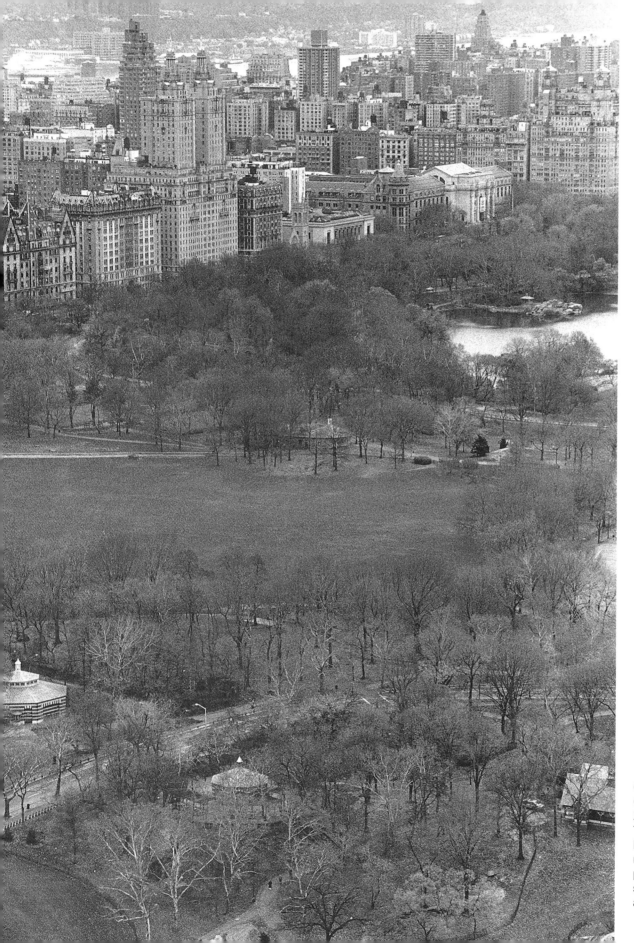

From a high-rise building on 57th street, looking West : the Sheep Meadow (center) and the "Dakota" apartment house (left).

The "Dakota" was named for that far away State because, when it was built in the 19th. century, it was so isolated from the then center of Manhattan.

Opposite page : Fifth Avenue on the right. Center : The Arsenal and the Children Zoo.

The rectangular shape of the 4,8 meter high (16 foot) Gates will reflect the geometry of the City blocks, while the fabric panels, moving in the wind, will mirror the shapes of the bare branches of the trees and the curvy design of the walkways.

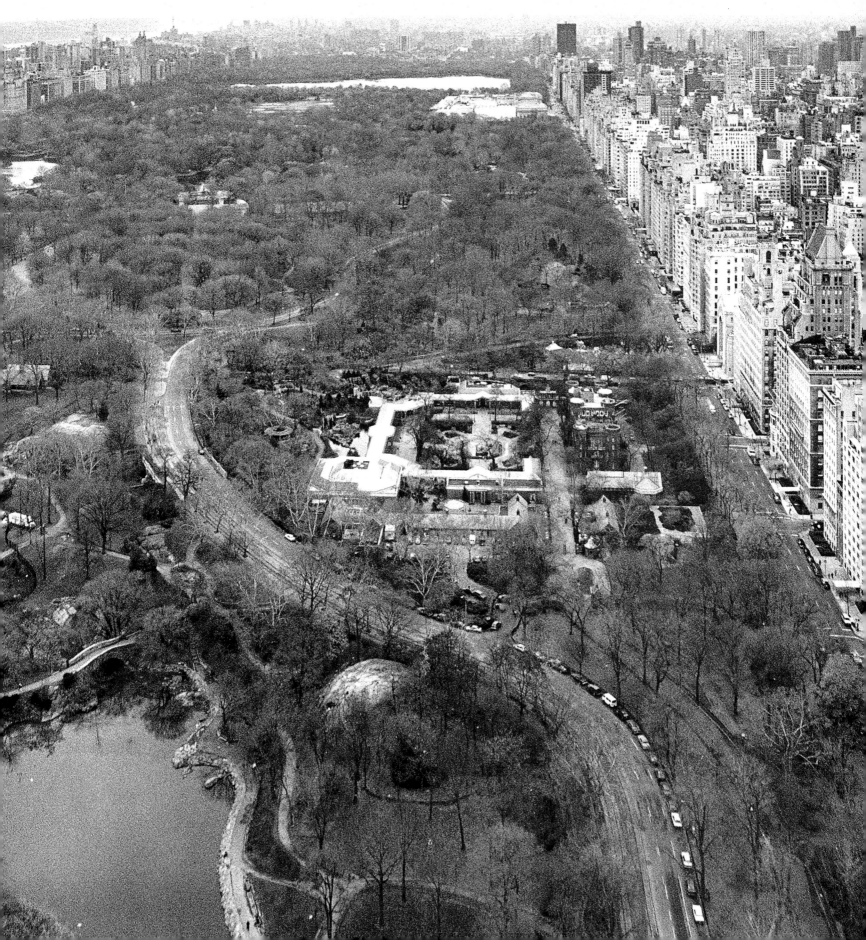

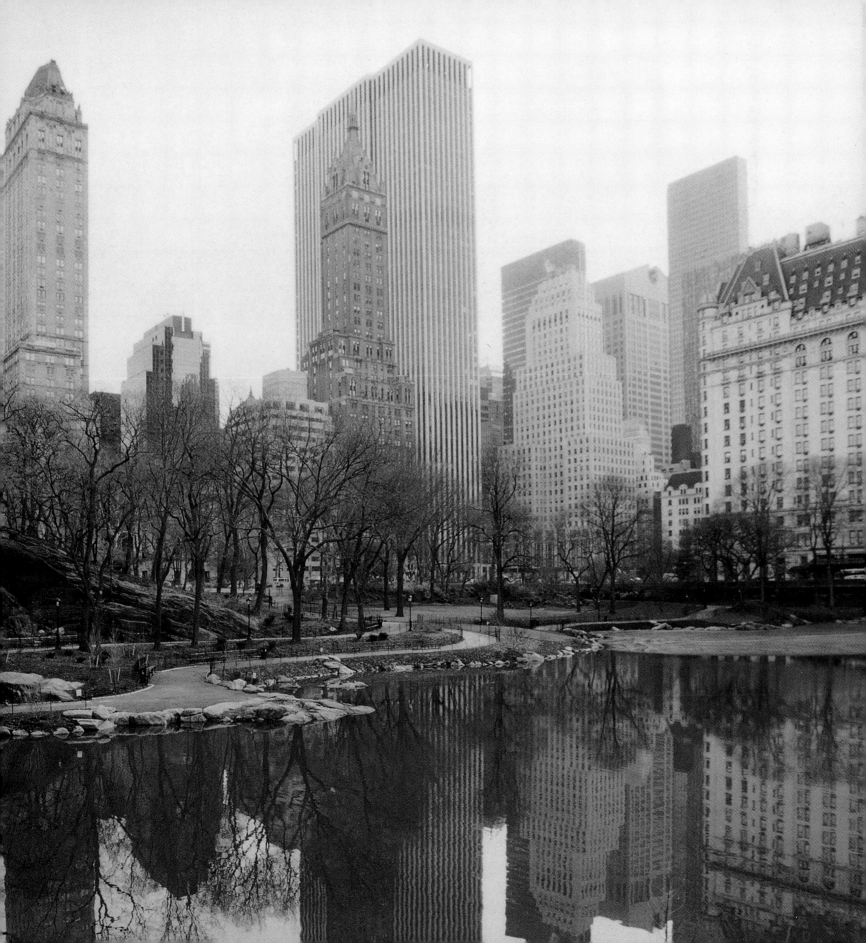

Opposite page: The Pond of Central Park mirrors the Plaza Hotel on the right, the General Motors building and the Hotel Sherry Netherlands on the left.

Below : Walkways near East 103rd Street. The Gates will be 4.8 meters (16 feet) tall, that is 1.5 meters (5 feet) taller than the lampposts which are 3.35 meters (11 feet) tall. The height of The Gates will remain constant while the width will vary according to the width of each walkway.

Below right : Walkways near East 62nd Street looking at Central Park South on 59th Street.

Next spread : Walkways near 79th Street, the Belvedere Lake reflects some of the surrounding buildings. The Great Lawn is in the center.

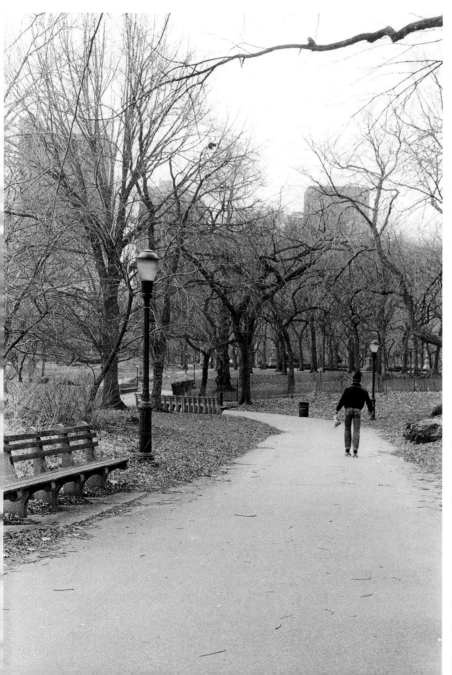

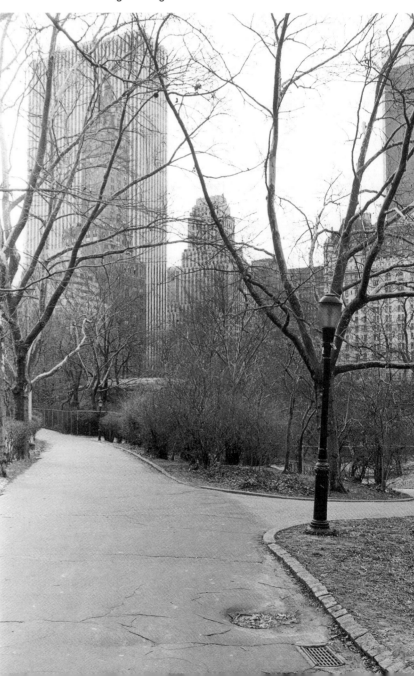

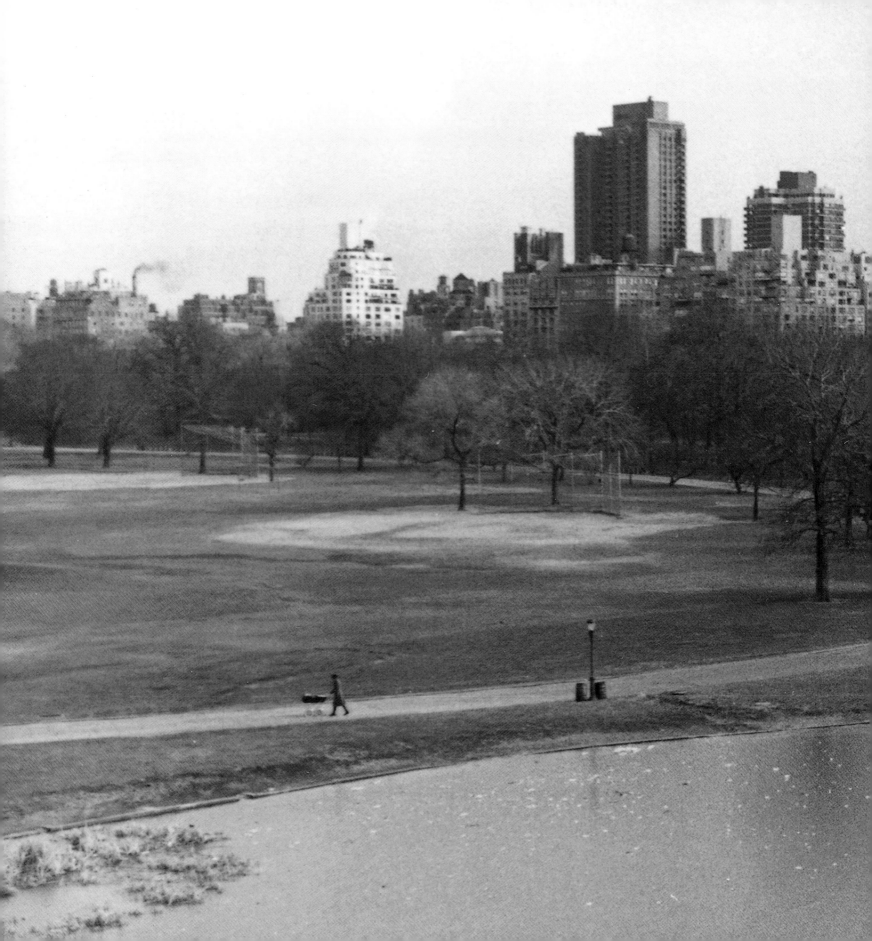

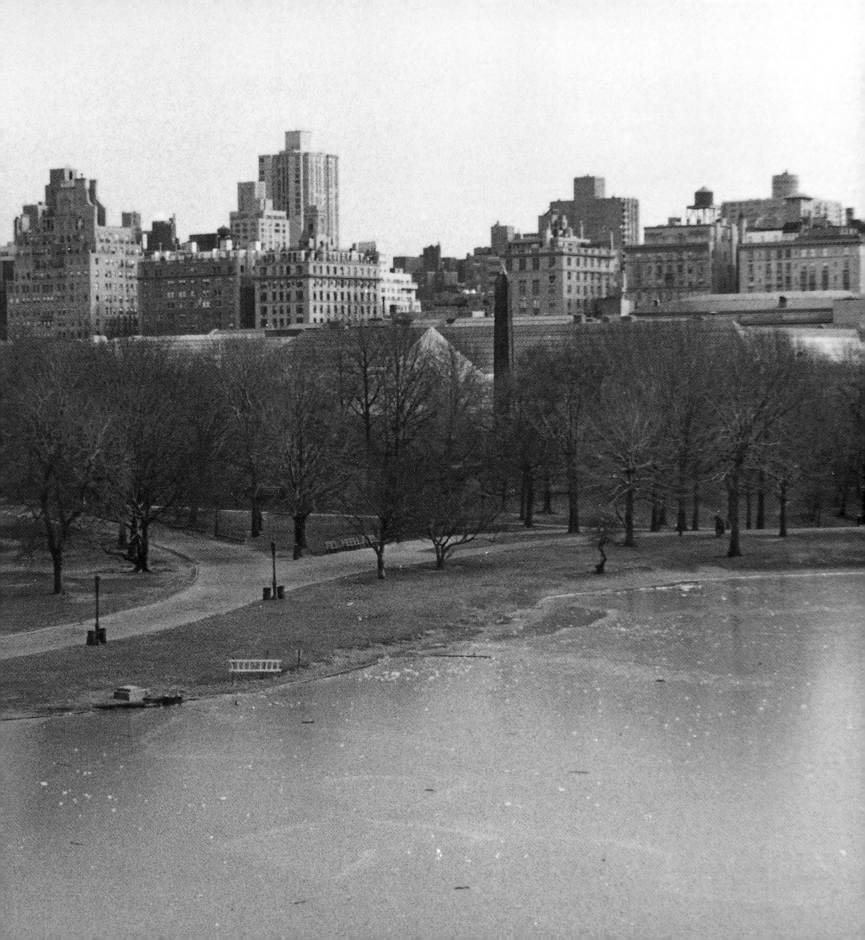

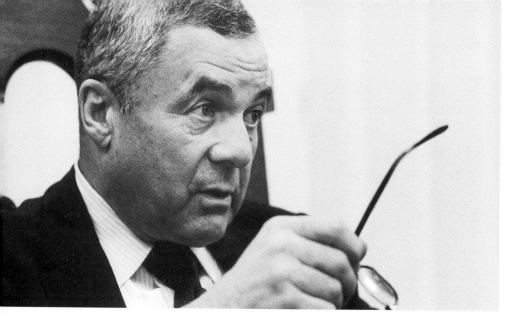

In 1979 long time friends and art collectors Kimiko and John Powers advised Christo and Jeanne-Claude to seek the help of a lawyer. They recommended New York attorney Theodore J. Kheel a specialist in labor negotiations and also great friend of the arts. In February 1980 the artists flood the lawyer's office desk with an extensive amount of information on past projects and about The Gates. Ted Kheel points out that he is not a friend of the Mayor of New York. The artists insist that even so they want him to represent them in the labyrinth of negotiations.

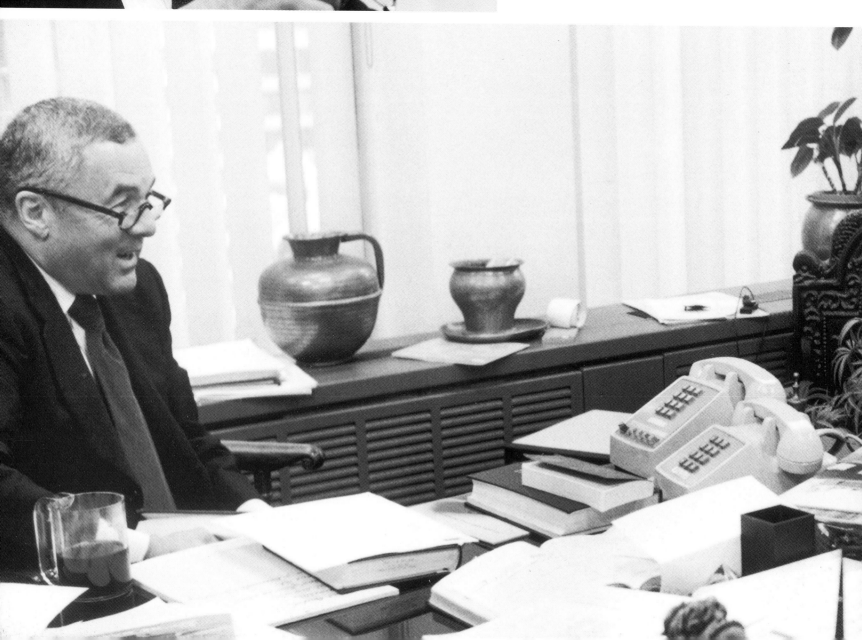

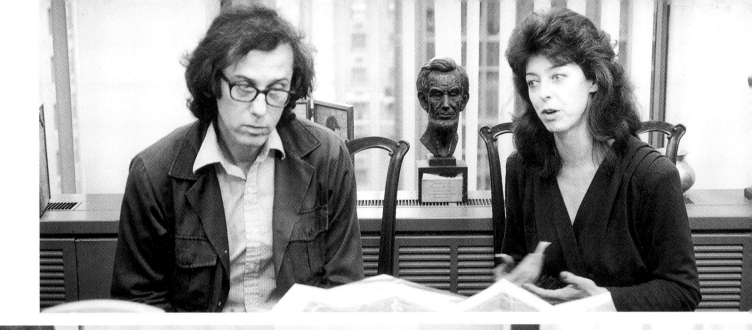

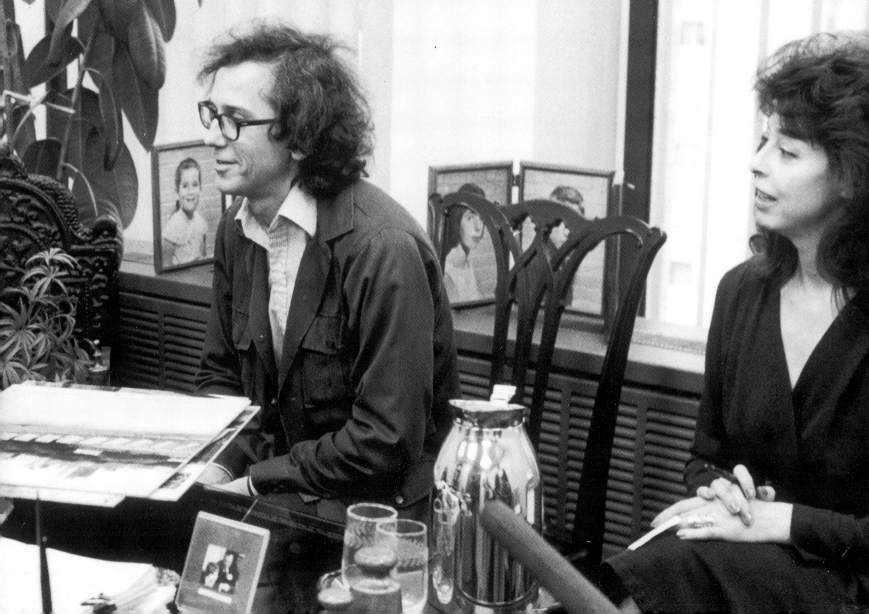

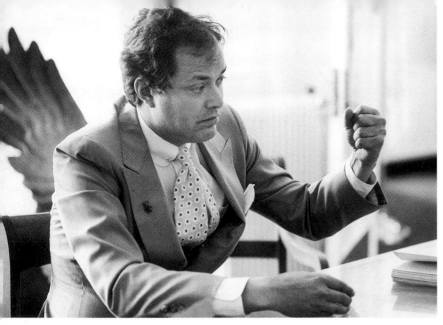

Losing no time, Christo, Jeanne-Claude and Ted Kheel find themselves on April 22, 1980 at The Arsenal in Central Park, in the office of Gordon J. Davis, Commissioner of Parks and Recreation of the City of New York (left).

The artists have brought visual material about The Gates and books about past projects. They are quite tense while Theodore Kheel (opposite, top) explains the legal ramifications to Gordon Davis who also is an attorney.

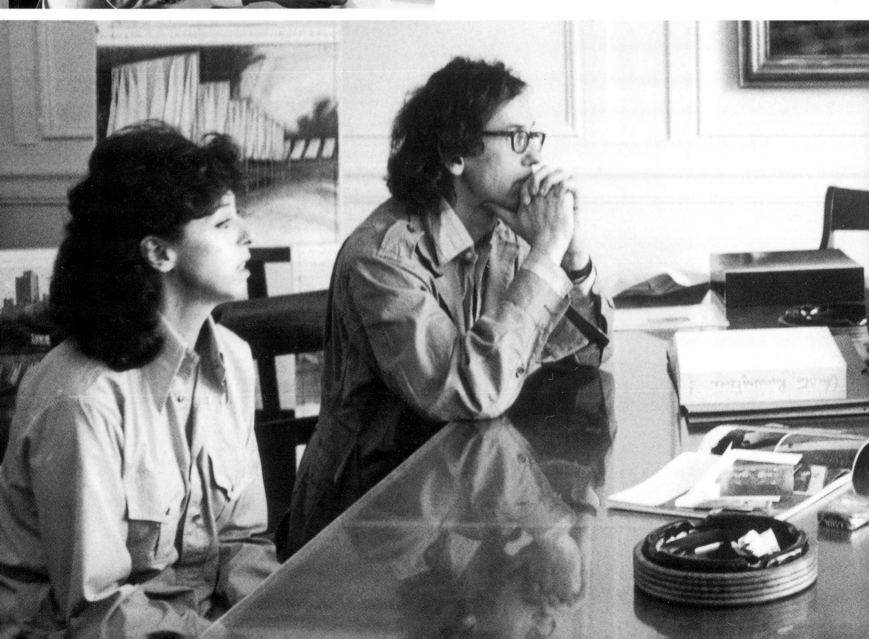

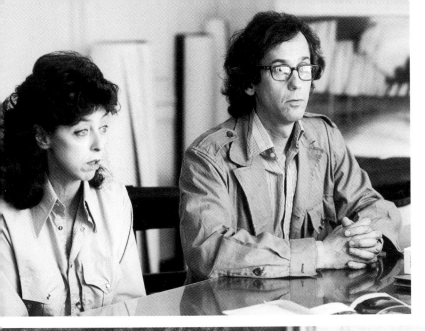
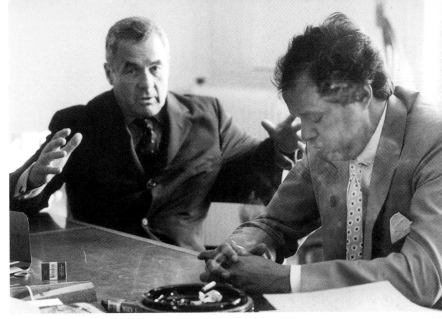
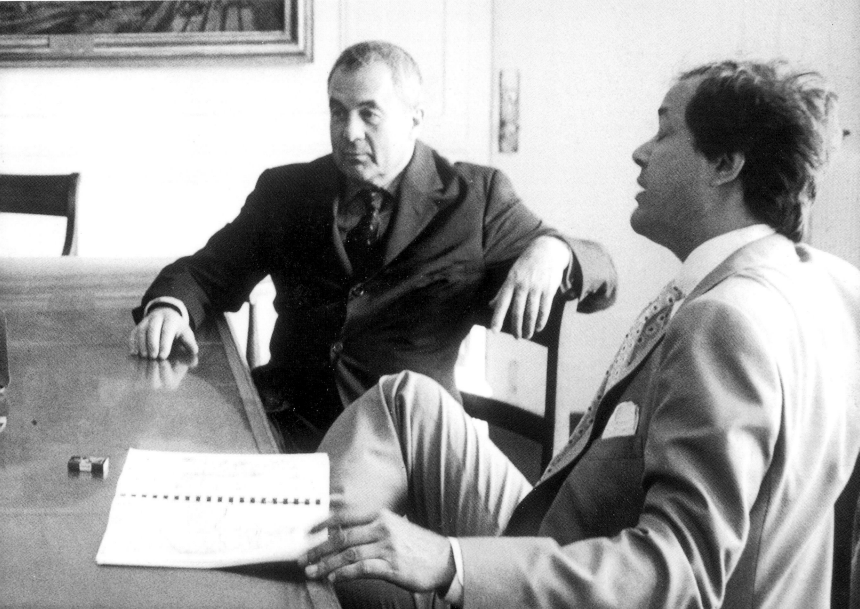

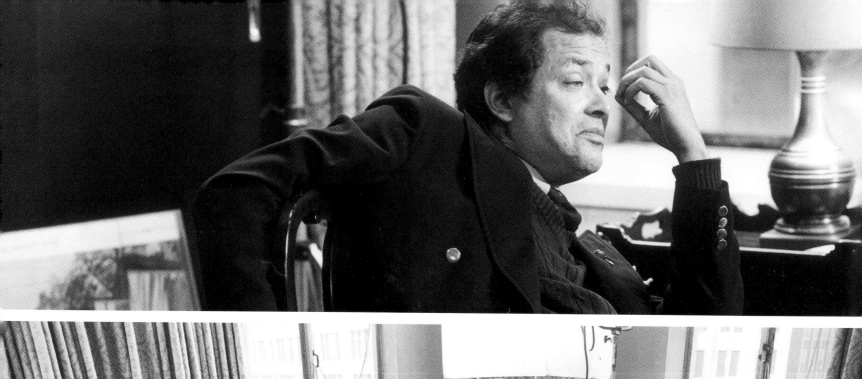

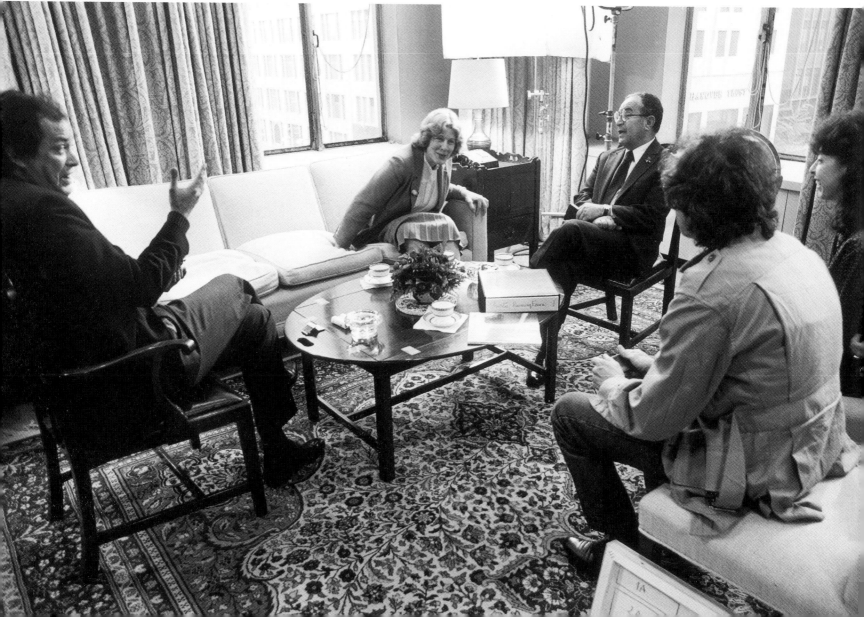

A few days later on April 29, at the office of Martin Segal, an influential New Yorker and friend of the arts (BELOW) a meeting takes place with the artists, Gordon Davis (opposite) and Agnes Gund (below, right) patron of the arts and friend of Christo and Jeanne-Claude.

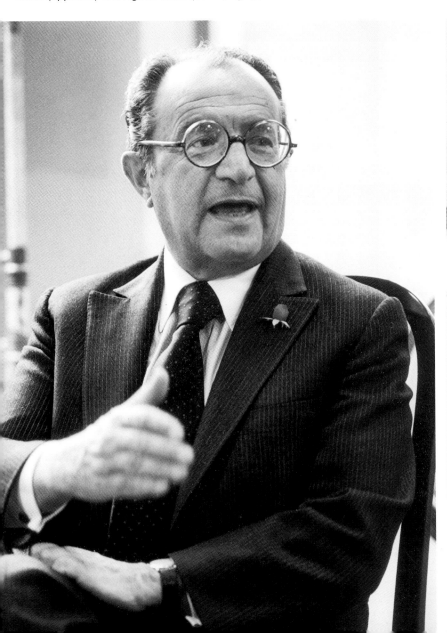

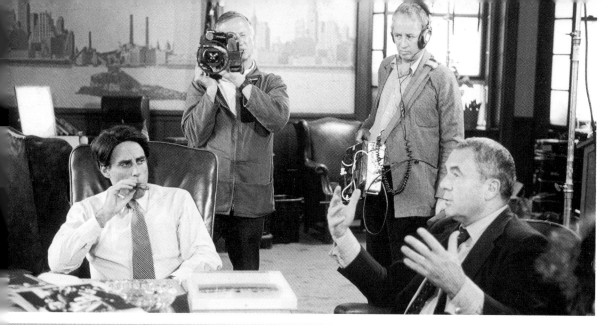

The City of New York is divided into five boroughs, Manhattan, Queens, Brooklyn, The Bronx and Staten Island. Ted Kheel has arranged the appointment of May 21, 1980 at the office of Andrew Stein, President of the Borough of Manhattan.

On the left : Andrew Stein smoking his cigar, discusses with Ted Kheel while Albert Maysles films and David Maysles records the sound. The meeting is warm and the artists discover a great ally in Ellen Hay, executive administrator of Andrew Stein (opposite page, near).

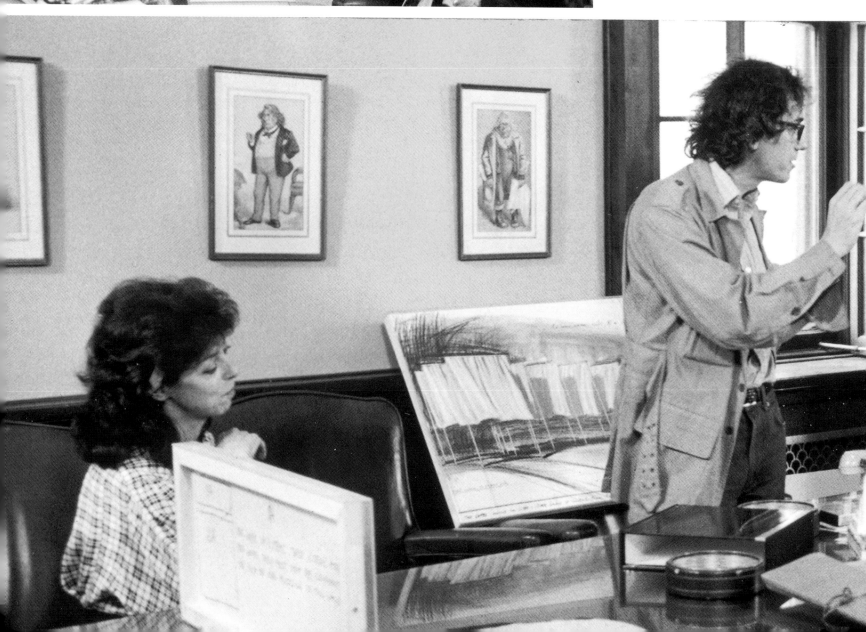

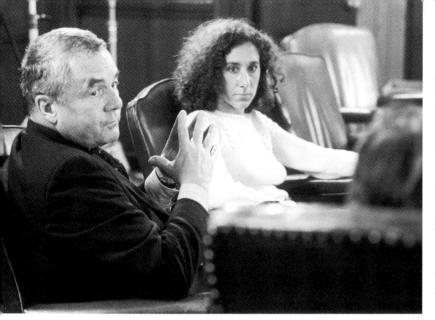

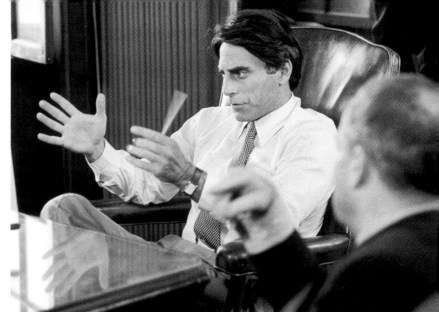

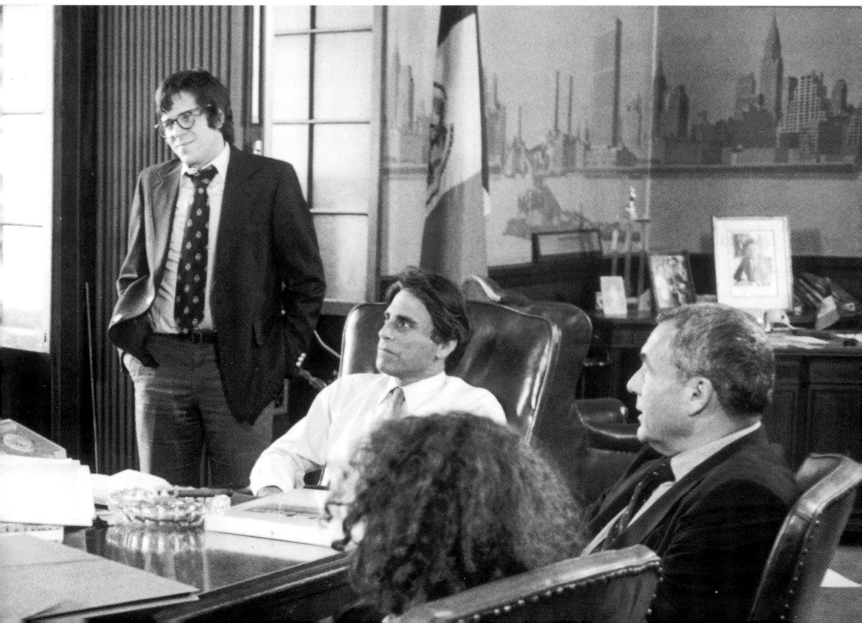

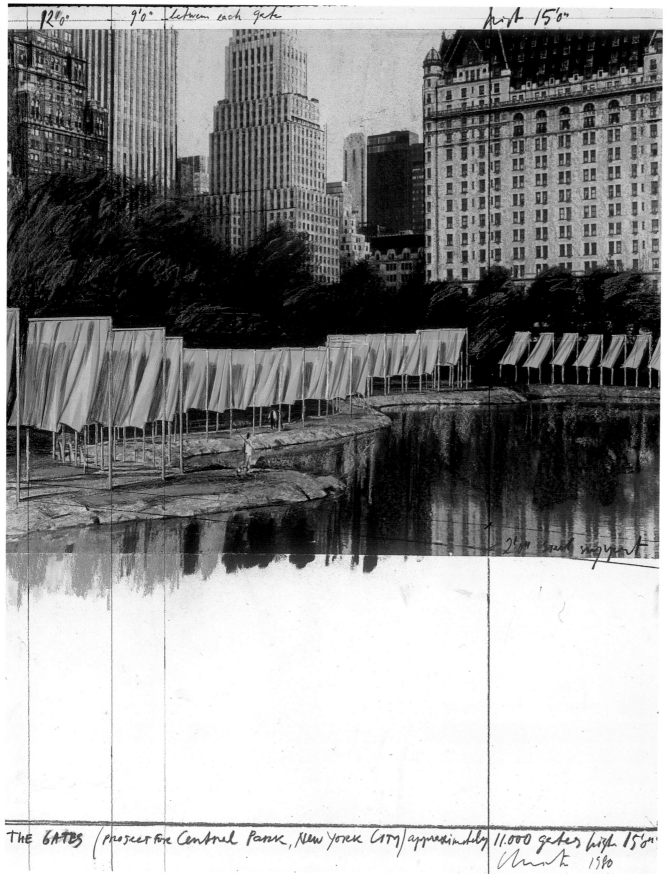

12'0"　　　　9'0" between each gate　　　　　　　high 15'0"

2'm steel support

THE GATES (project for Central Park, New York City) approximately 11.000 gates high 15'0"

Christo 1980

The Gates, Project for
Central Park, New York City.
Collage 1980.
71 x 56 cm (28 x 22").
Pencil, fabric, photograph by
Wolfgang Volz, pastel and
charcoal.

On June 9, 1980 Christo and Jeanne-Claude pay a visit to their long time friend Henry Geldzhaler the Commissioner of Cultural Affairs (right) and his assistant Randall Bourscheidt. Henry used to be Curator of 20th Century Art at the Metropolitan Museum. They are great supporters and try to find ways to help in that New York City tightrope exercise.

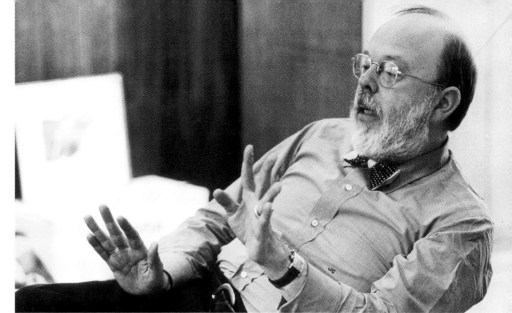

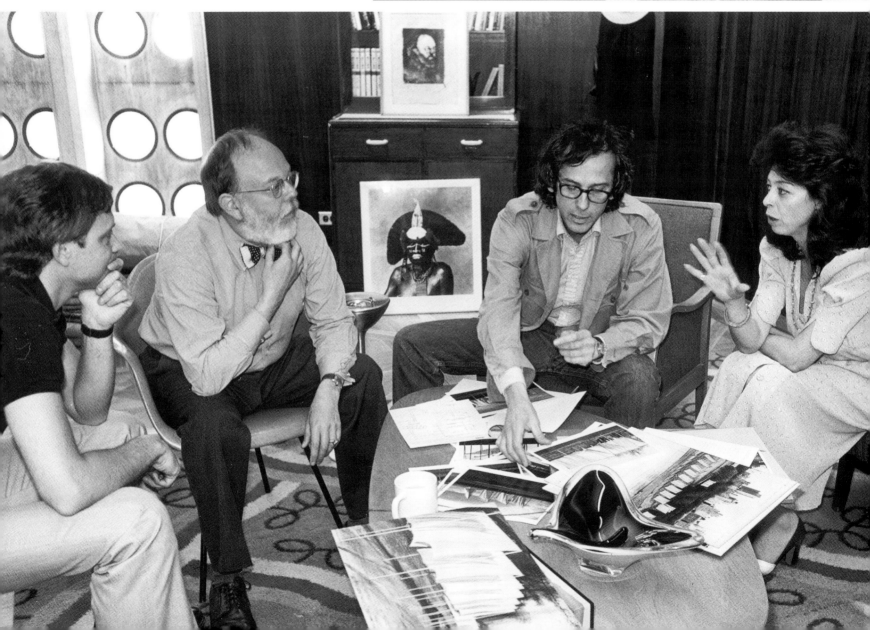

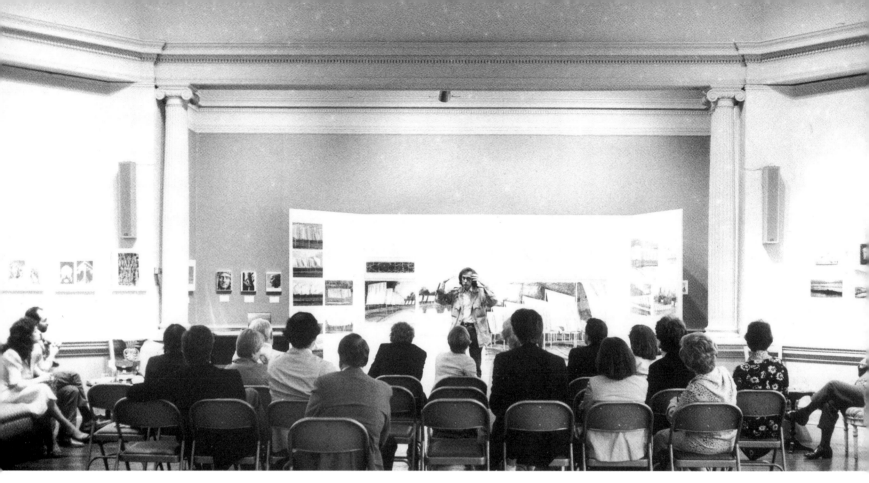

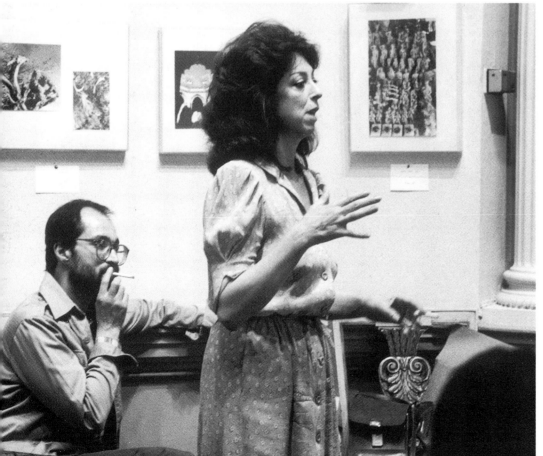

On June 12, 1980, during a meeting hosted by Martin Segal at the Century Club, Christo (above) explains The Gates project to the guests of Henry Geldzhaler and Gordon Davis (an interesting mixture of pro and con). Jeanne-Claude (left), is answering questions. The artists' friend Harrison Rivera-Terreaux sits behind her. Gordon Davis (opposite, top) answers questions about the delicate and mixed positions of the members of the Central Park Conservancy. Henry Geldzhaler (opposite, bottom) forcefully expresses his enthusiasm for the project. In his position as Cultural Commissioner, amongst other duties, he has to grant financial support to artists and he is most pleased to emphatically point out that Christo and Jeanne-Claude always pay for all their projects with their own money.

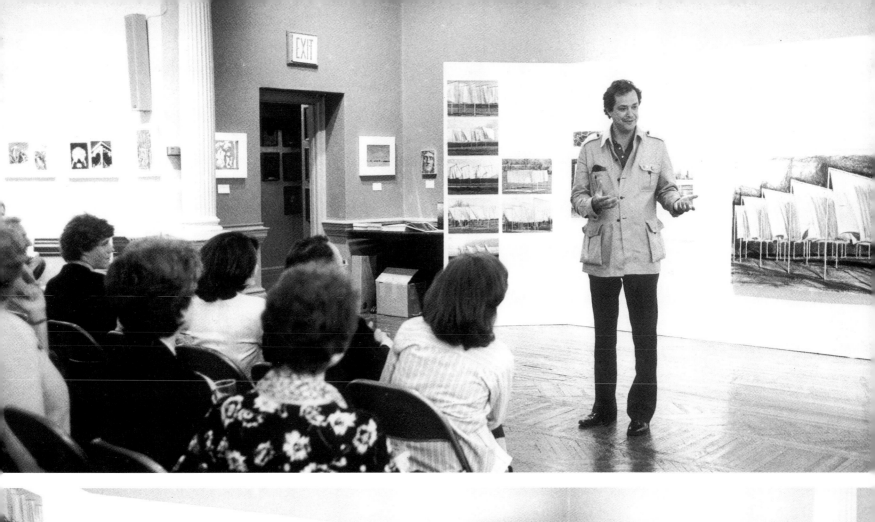

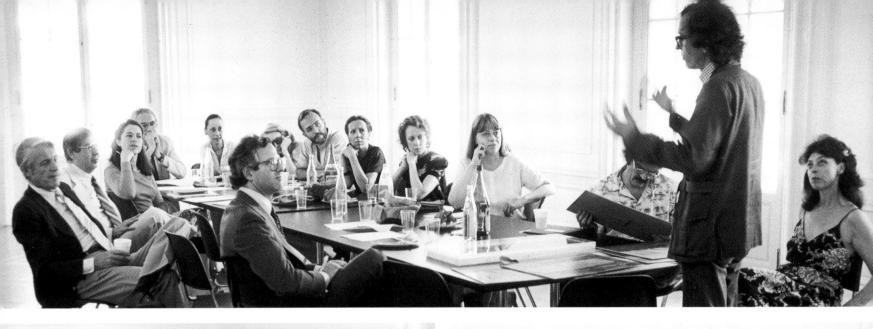

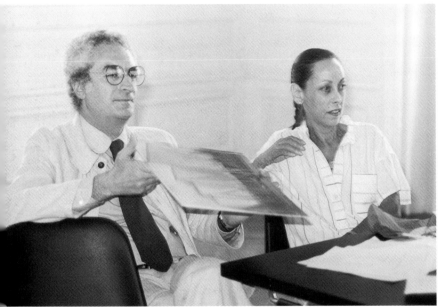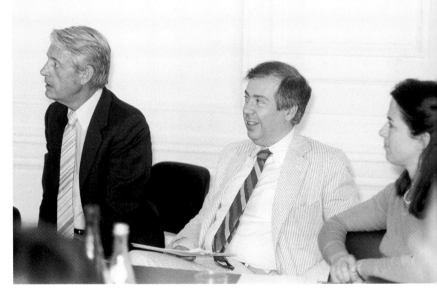

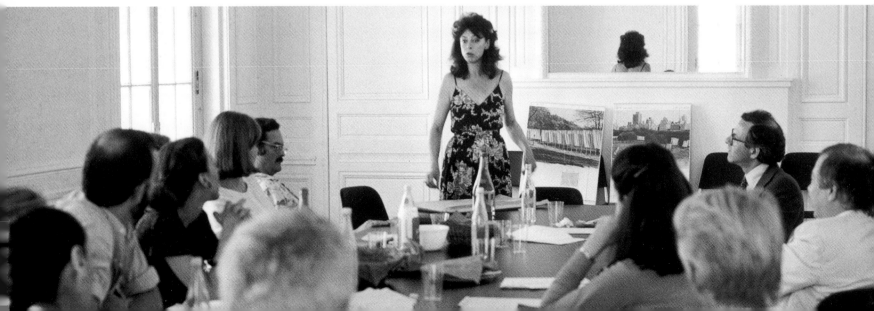

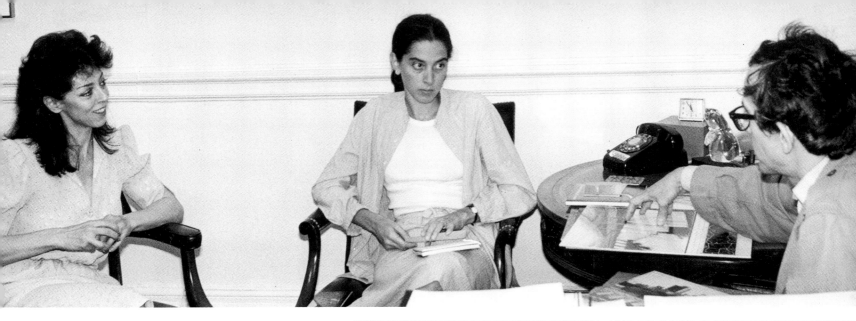

At the Architectural League of New York (opposite, top) on June 25, 1980 Christo explains the project to fellow Board Members. Amongst them (opposite page, center, left) Massimo Vignelli and Barbara Jakobson. Opposite page, center, right, architect Ulrich Franzen, Jonathan Barnett president of the League and Marita O'Hare Executive Director. Jeanne-Claude answers questions and explains that the artists are counting on the league to spread the good word in New York social groups since Christo is a Board Member.

Above : At City Hall on September 16, 1980 Christo and Jeanne-Claude try to convince Ronay Menschell, the Mayor's Executive Administrator to arrange an appointment with the Mayor of New York City.

Great supporter of the project, (right) Lisa Taylor, Director of the Cooper-Hewitt Museum, promises to talk to all those people not easily accessible to the artists.

The curator of the Museum of the City of New York, Steven Miller, (right, bottom) assures the artists on August 27, 1980 that they may count on his support.

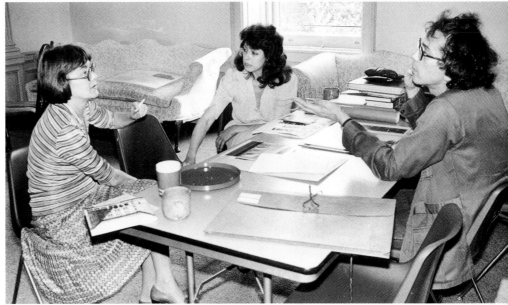

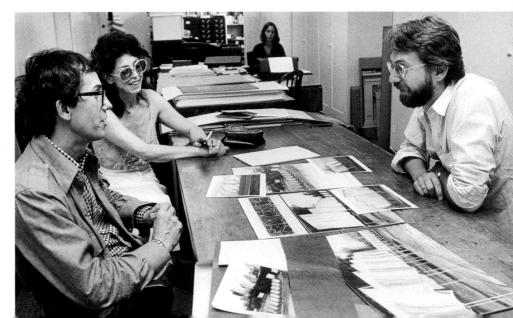

At the Museum of Modern Art in New York, on September 9, 1980 Christo answers questions from the guests of Parks Commissioner Gordon Davis and Manhattan Borough President Andrew Stein.

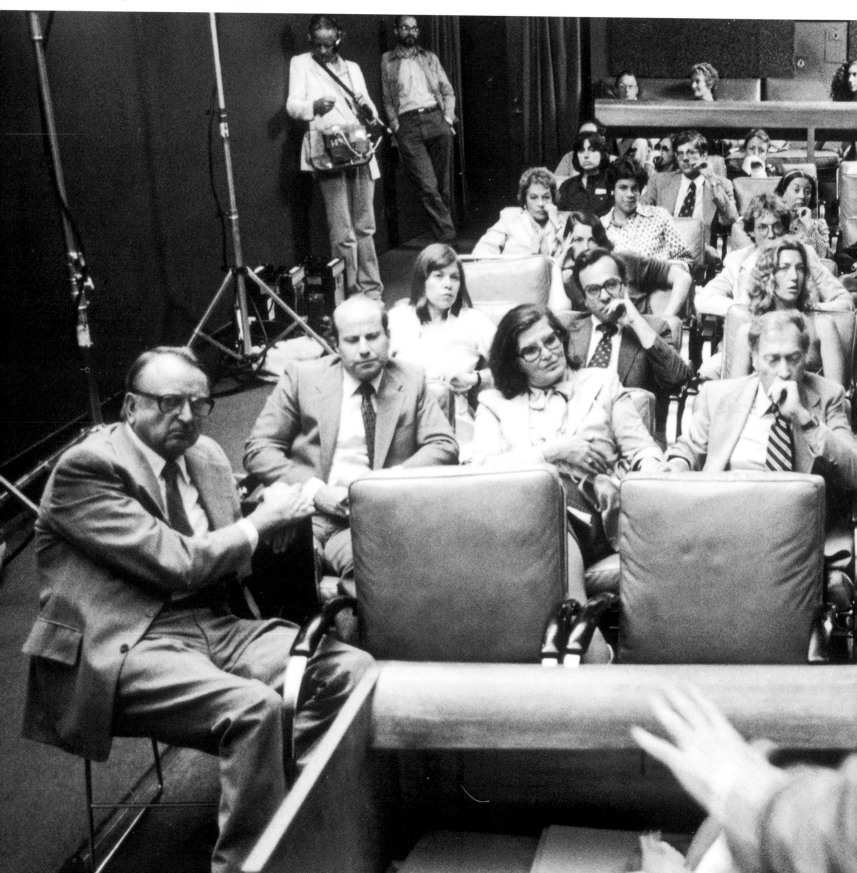

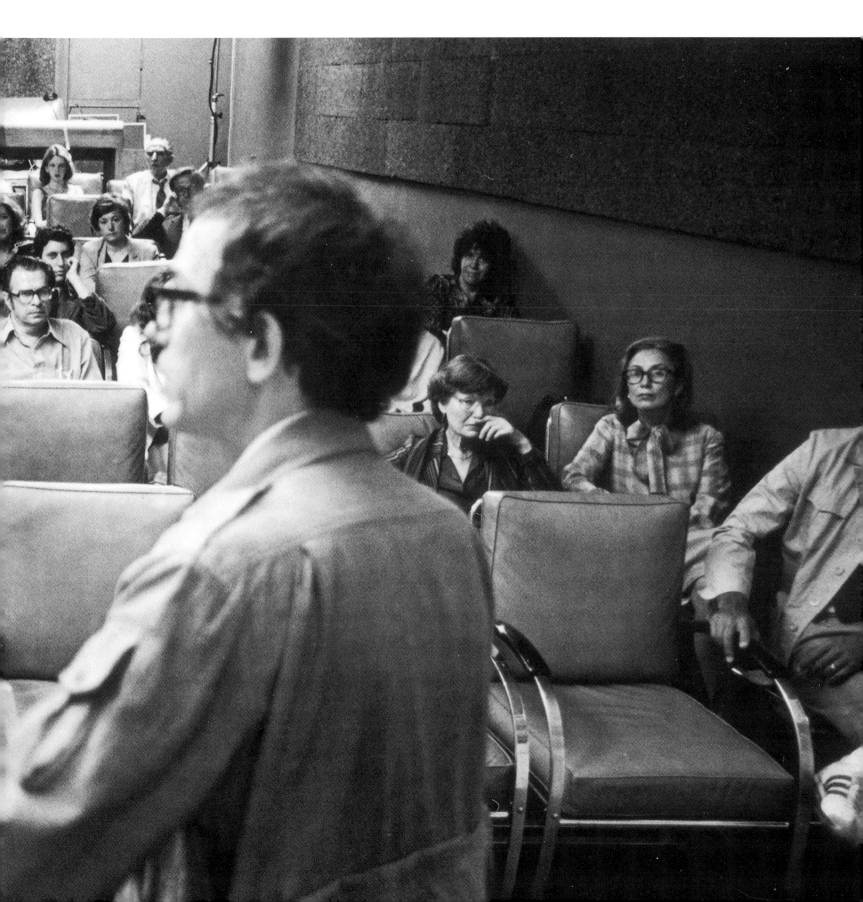

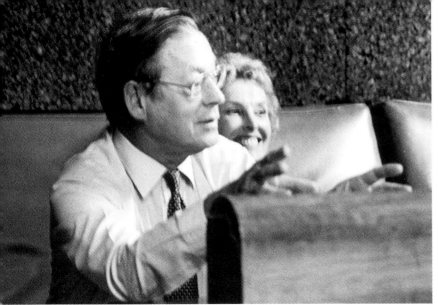

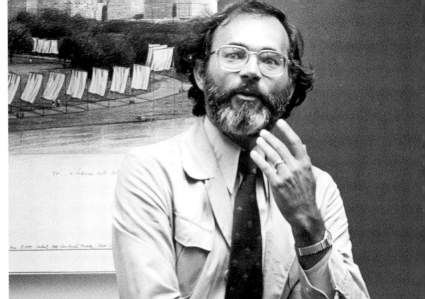

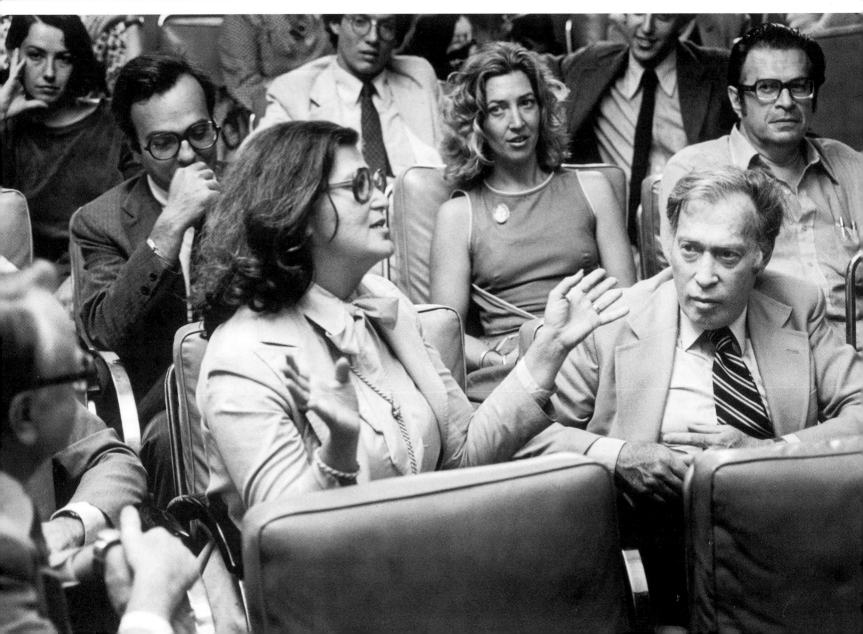

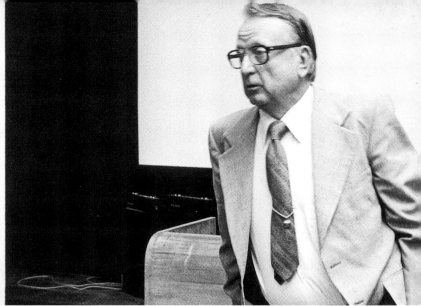

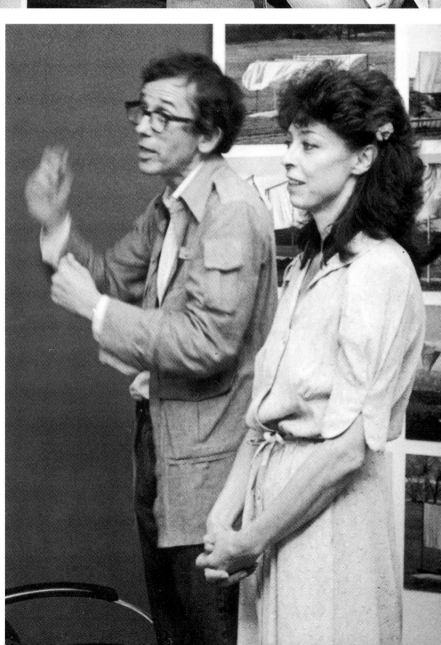

During the meeting at the Museum of Modern Art many questions arise. The New York Times Corporation Board Member Sidney Gruson and Marit Gruson (opposite page, top left), are friends of the project.

Joseph P. Bresnan, Director of Historical Parks and Deputy Director of Parks and Recreation answers questions on behalf of the Park Department (opposite page, top right).

Sally Goodgold, Chairperson of Community Board # 7 explains that her board is in favor of the project (opposite page, bottom).

When the question is technical Christo asks his friend Theodore Dougherty to answer it (above). Ted is an engineer and the builder contractor who has been in charge of all the projects since the 1972 *Valley Curtain* in Colorado.

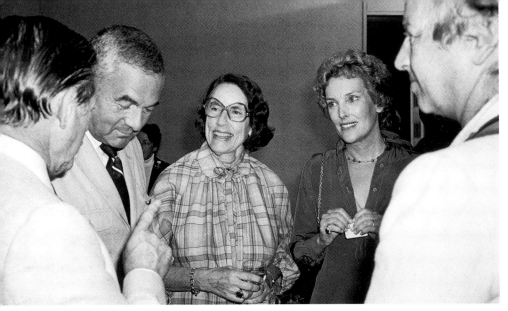

After the meeting at the Museum of Modern Art, friends comment on the variety of questions.
Top : Sidney Gruson, Ted Kheel, Ann Kheel, Marit Gruson and film maker David Maysles.
Center : Ted Dougherty and Agnes Gund.
Bottom : Christo, Cathie Berend and Joseph Bresnan.

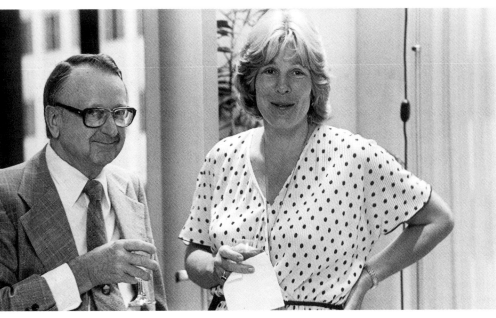

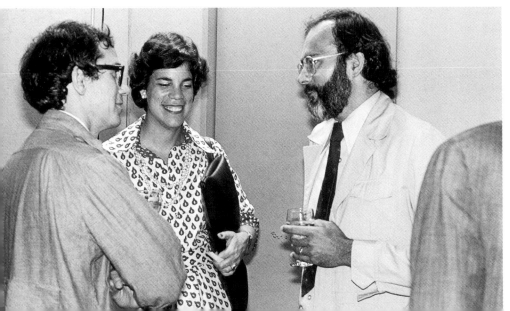

Top : New Yorker Magazine writer, author and great supporter Brendan Gill with a friend.
Center : Christo, Joseph Bresnan and Chicago attorney Scott Hodes, art collector and long time friend of the artists.
Bottom : Christo answers questions from a representative of Community Board # 5.

Andrew Stein requests that the artists explain the project to all Community Boards around Central Park. Even though the Boards have no legal jurisdiction on Central Park, their opinion as citizens is important to the authorities in City Hall.
There are five community boards adjacent to Central Park:
Board # 5 from Central Park South down to 14th Street (midtown and midtown South).
Board # 7 between Central Park West and the Hudson River (upper west side).
Board # 8 east of Central Park, between 59th Street and 96th Street (upper east side).
Board # 10 between Central Park North, 162nd Street and the Harlem River.
Board # 11 between east of fifth Avenue and the East River (East Harlem).

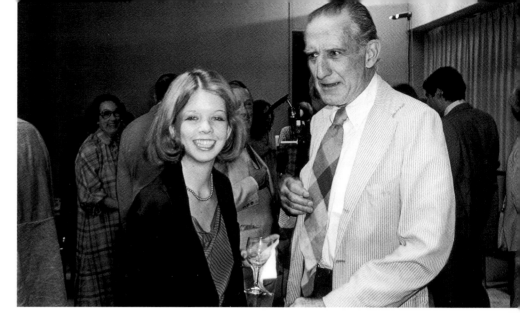

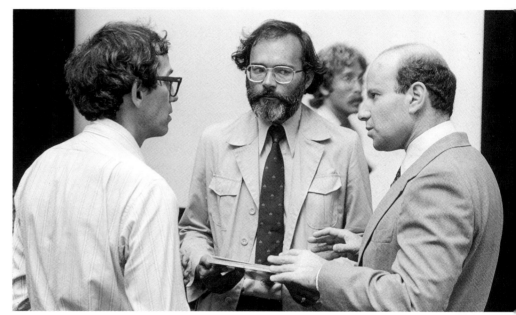

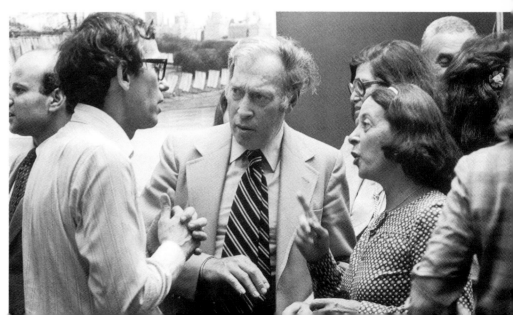

Presentation to the members of Community Board # 7, between Central Park West and the Hudson River (Upper West Side), at the "Jewish Family Home". Chairperson Sally Goodgold presides over the December 2, 1980 session.

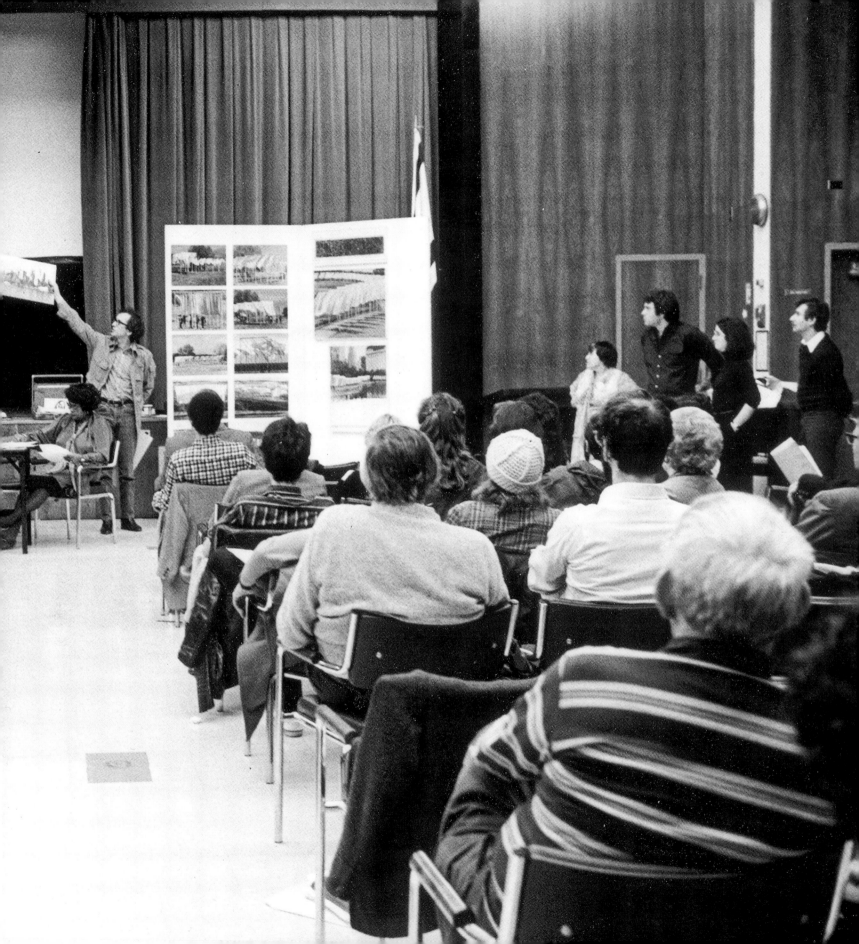

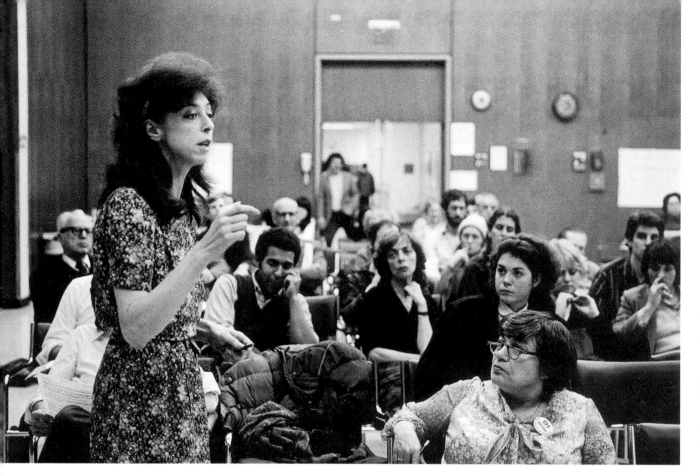

Jeanne-Claude patiently answers questions from the members of Community Board # 7 (left).

As with each of the four Community Board meetings, the artists ask their three professors : soil specialist, ornithologist and arborist to be present.

As a soil expert Professor Roy Flannery of Rutgers University, New Jersey (left, bottom) explains that the holes made in the ground of Central Park to support the sleeves of the steel gates on each outer side of the walkways will be beneficial to the park since the artists will have the holes filled with better soil after the removal of the work of art.

Opposite page, bottom: Professor Spencer Davis Jr. Executive Director of the American Arborist Society assures the audience that The Gates will stay away from the roots of the trees. Richard Plunkett, staff ecologist and ornithologist at the National Audubon Society has stated to the audience that the season of the migration of the birds in Central Park would have ended by the time of the exhibition of The Gates.

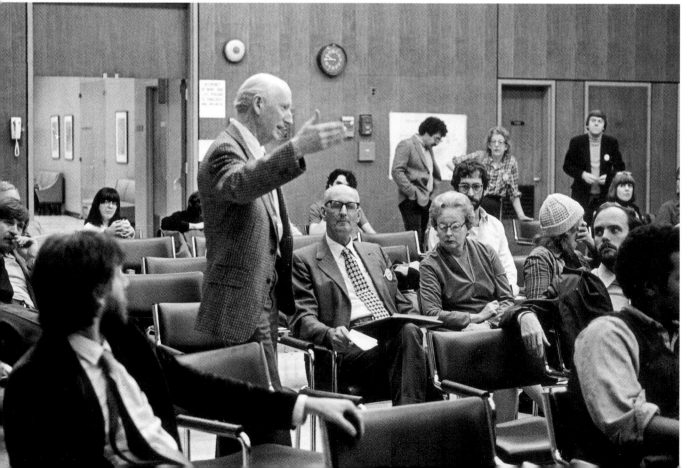

On December 2, 1980 Attorney Theodore Kheel explains to the members of Community Board # 7 that a written contract shall be drafted between the Department of Parks and the artists. The contract shall require Christo and Jeanne-Claude to provide :

– Personal and property liability insurance holding the Department of Parks harmless.
– Removal Bond providing funds for complete restoration of the site.
– Full cooperation with the Community Boards, the Department of Parks, the New York City Arts Commission, and the Landmarks Commission.
– Clearance for the usual activities in the Park and access of Rangers, maintenance, clean-up, Police and Emergency Service vehicles.
– The artists shall pay all direct costs of the Park's supervision related to the project.
– Neither vegetation nor rock formations shall be disturbed.
– Only vehicles of small size will be used and will be confined to the perimeter of existing walkways during installation and removal.
– Great precaution will be taken so as not to interfere with any of the wildlife patterns.
– The site shall be inspected by the Department of Parks who will be holding the Bond until full satisfaction.

After hearing the presentation, asking questions and hearing the answers Community Board # 7 votes in favor of The Gates.

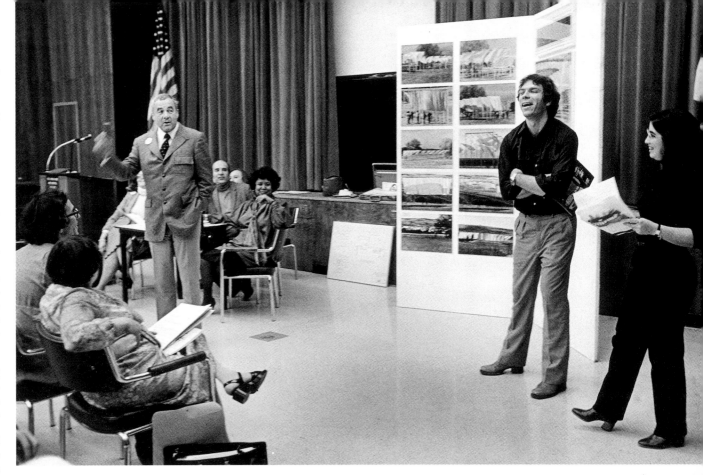

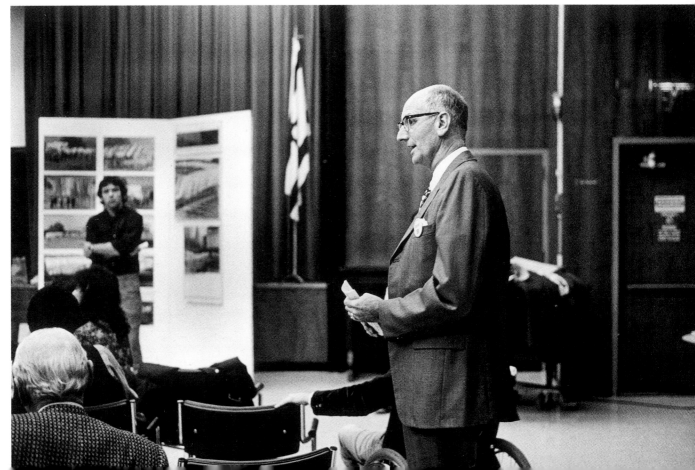

February 1981 presentation to the members of Community Board # 10 between Central Park North, 162nd Street and the Harlem River.
They vote in favor of the project.

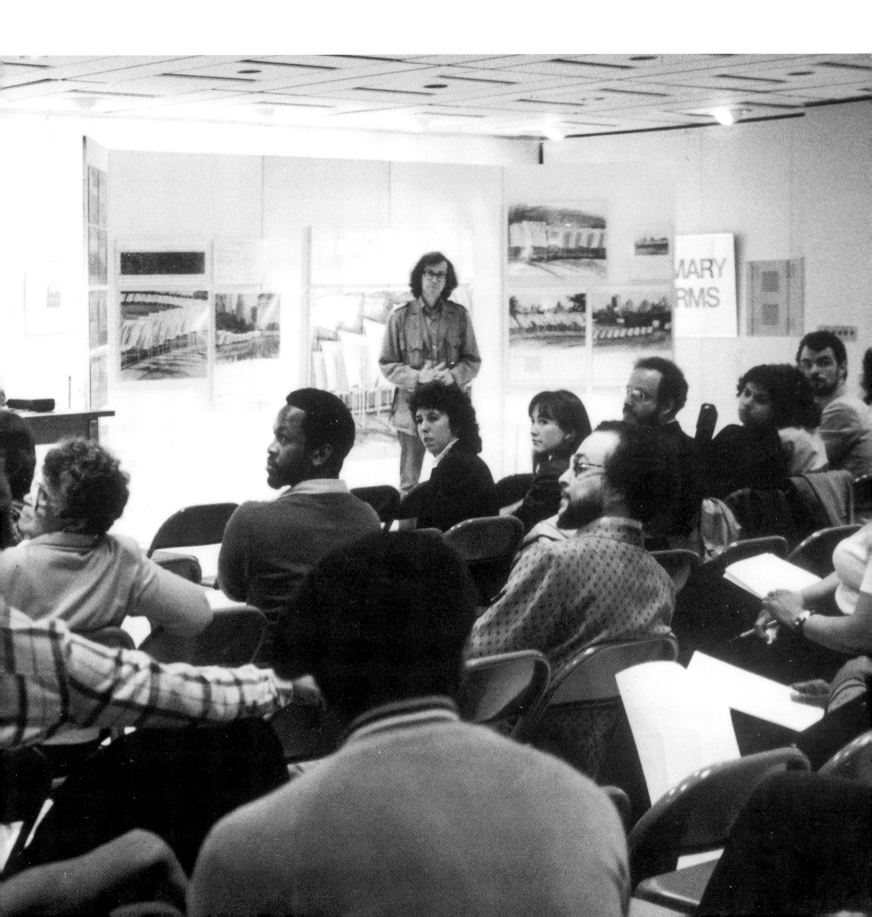

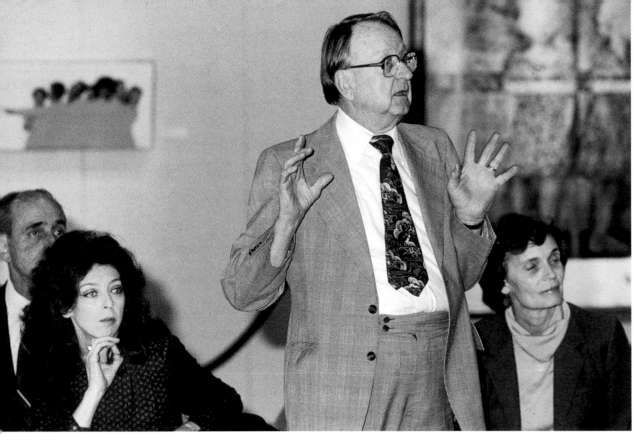

At the Meeting of Community Board # 10 (left) in February 1981 (from left to right) : close friend of the artists and art collector Thomas M. Golden, Jeanne-Claude, engineer and builder contractor Theodore Dougherty and Phyllis Dougherty listen to the many questions asked by the Board members. Ted explains the construction details.

Below, left : Paul Zigman of Environmental Sciences Associates, California, explains how his company had prepared the Environmental Impact Report for the 1976 temporary work of art *Running Fence* in Northern California.

Below : Always convincing, Theodore Kheel is already thinking of recruiting local workers.

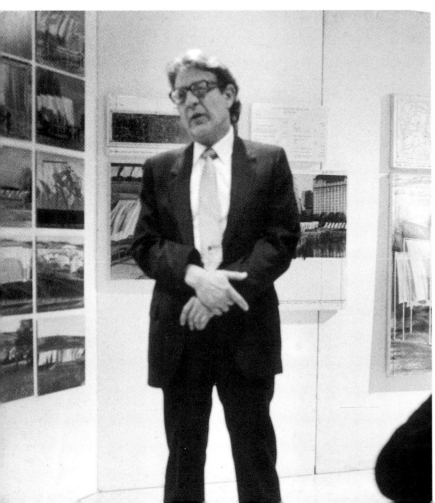

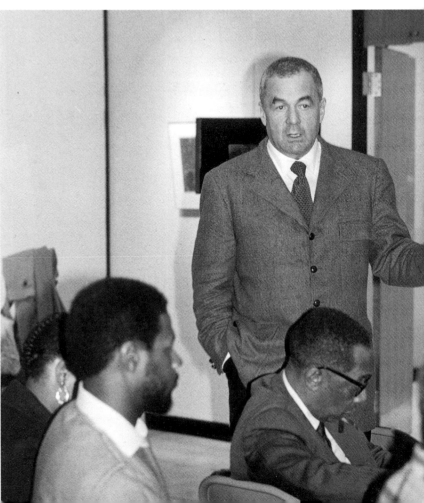

Sociologist Dr. Kenneth Clark (right, wearing glasses) is gathering information for the Human Impact Study which he is preparing on behalf of Christo and Jeanne-Claude. The extensive research for the Study involves interviewing passers-by and residents around Central Park, and asking questions on the telephone as well as a few seminars at the Clark, Phipps, Clark and Harris office.

Participants are eager to let all Board members know that the employment provided by the art project is to be welcomed.

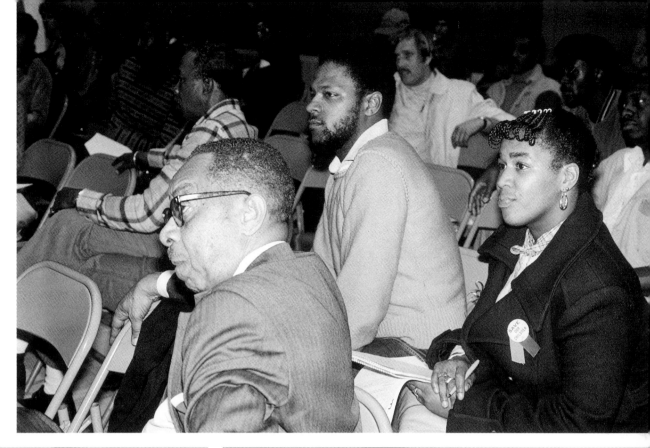

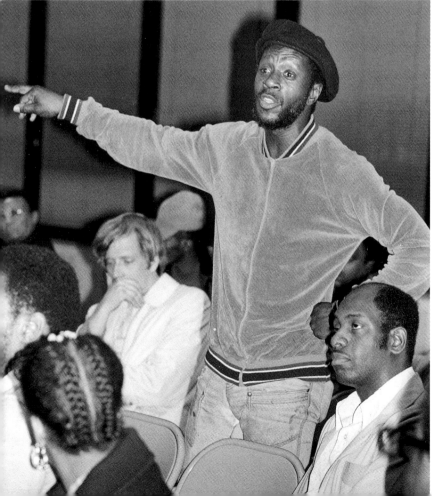

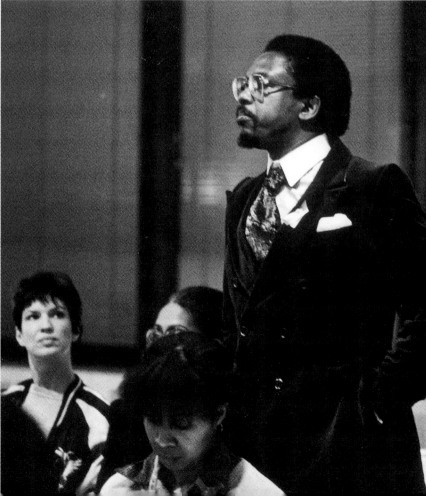

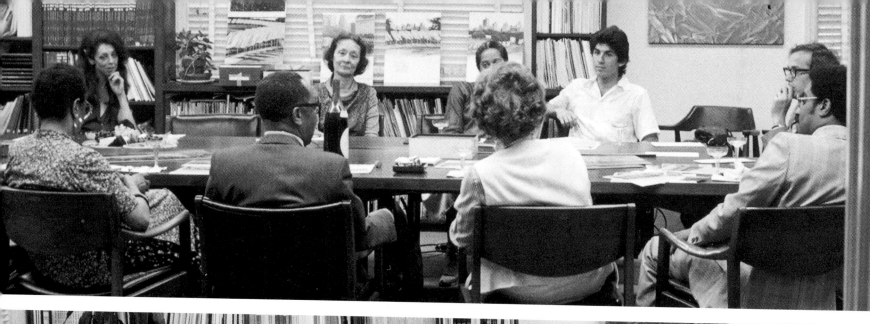

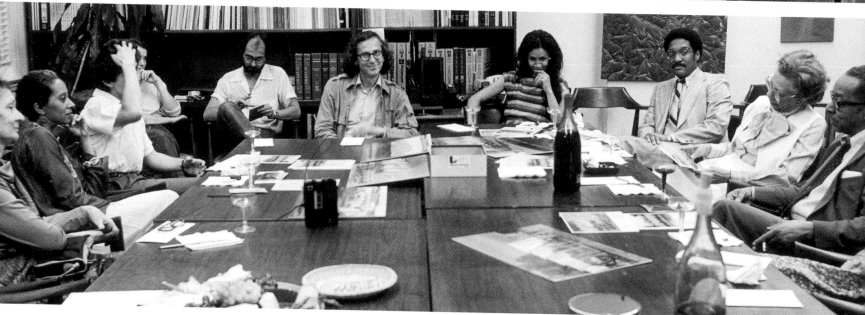

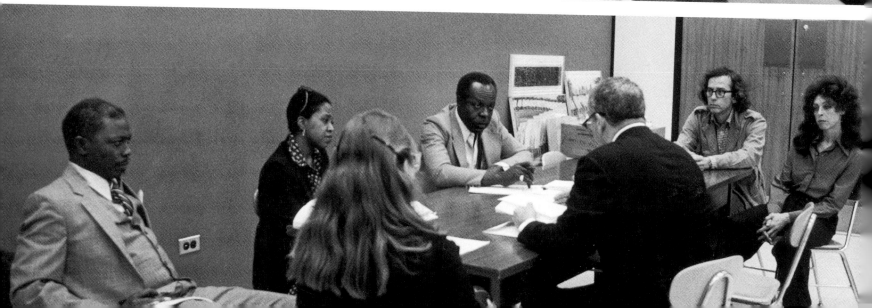

Starting in January 1981 many seminars are conducted (opposite page, top and center) at the office of Dr. Kenneth Clark in order to prepare the Human Impact Study about The Gates.

Four representatives of Community Board # 11 between East of Fifth Avenue and the East River (opposite page, bottom) during a February 1981 meeting with Theodore Kheel, Christo and Jeanne-Claude.
After the meeting, Community Board # 11 (East Harlem) votes in favor of The Gates.

RIGHT, TOP, Dr. Kenneth Clark explains The Gates project to some of the guests he has gathered at his office in preparation of the Human Impact Study.

During those seminars, Christo and Jeanne-Claude are sometimes present to answer questions but often Dr. Clark does not request them to attend, sensing that the audience tends to be freer in their questions without the presence of the artists.

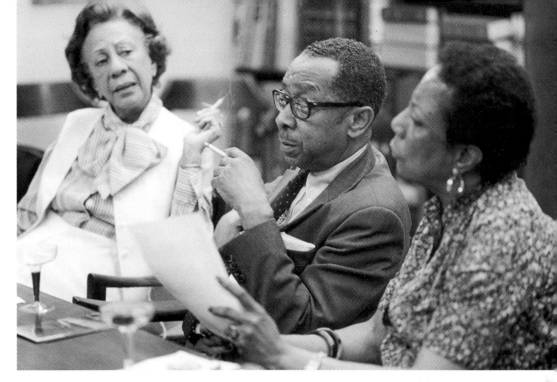

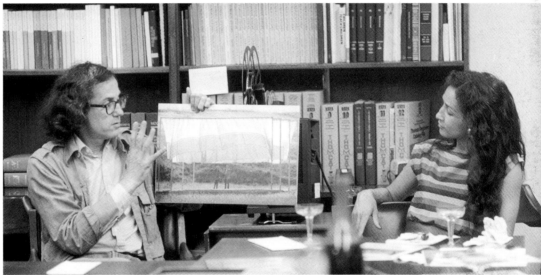

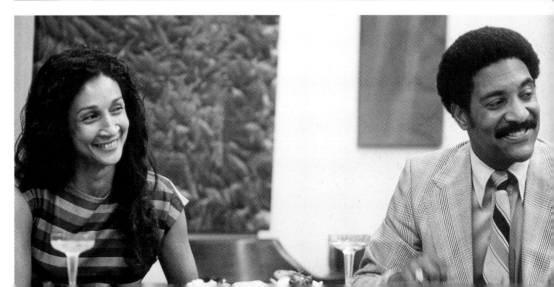

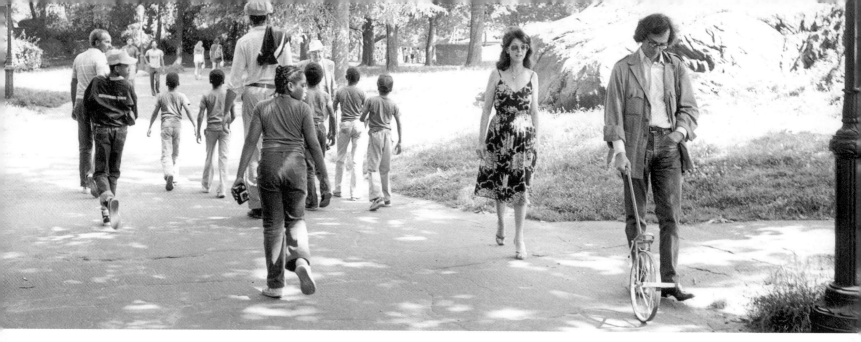

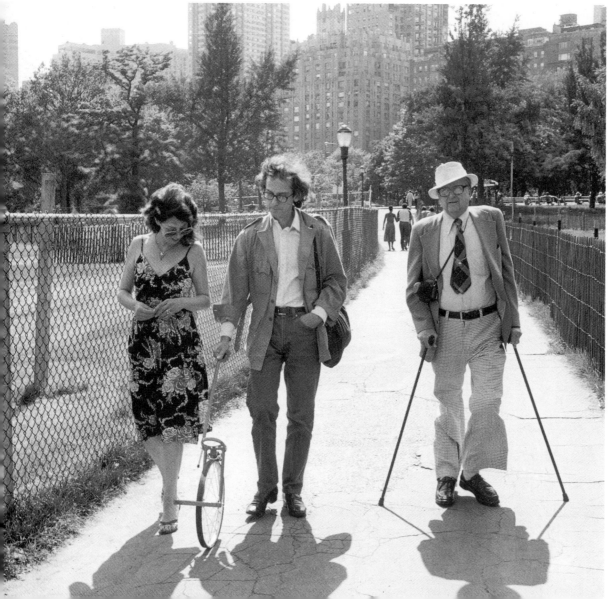

Christo, Jeanne-Claude and Ted Dougherty walking in Central Park to measure the walkways. They are holding a special wheel made to read the precise length of the ground on which it rotates.

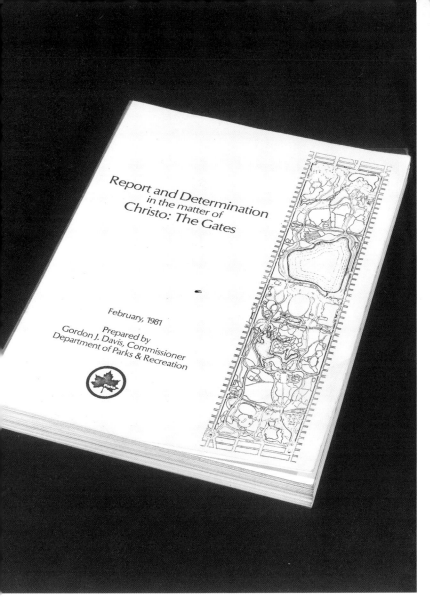

In February 1981 after months of preparation, Gordon J. Davis, Commissioner of the Department of Parks & Recreation issues a book titled : *Report and Determination in the matter of Christo : The Gates.* The 185 page book is published to answer, "NO" and to explain why permission has been denied.

After four presentations and answering questions from four of the Community Boards around Central Park :
Board # 5 votes against the project.
Boards # 7, # 10 and # 11 vote in favor of the project.
Board # 8 never agrees to meet with Christo and Jeanne-Claude.

In January 1982 the office of Dr. Kenneth Clark completed the Human Impact Study showing that the enthusiasm towards the project came from the less privileged citizens, while the richest neighbors of Central Park were mostly against.

This study states that the 14 day long work of art in Central Park will "… bring diverse groups of people together. It would be a unifying artistic event".

Christo and Jeanne-Claude completed the *Surrounded Islands* in Florida in 1983. *The Pont Neuf Wrapped*, in Paris in 1985, *The Umbrellas, Japan-USA* in 1991, and the *Wrapped Reichstag, Berlin*, in 1995. After which they have started again to negotiate the permits for *THE GATES, PROJECT FOR CENTRAL PARK*.

Next pages: 21 years later - June to September 2002.

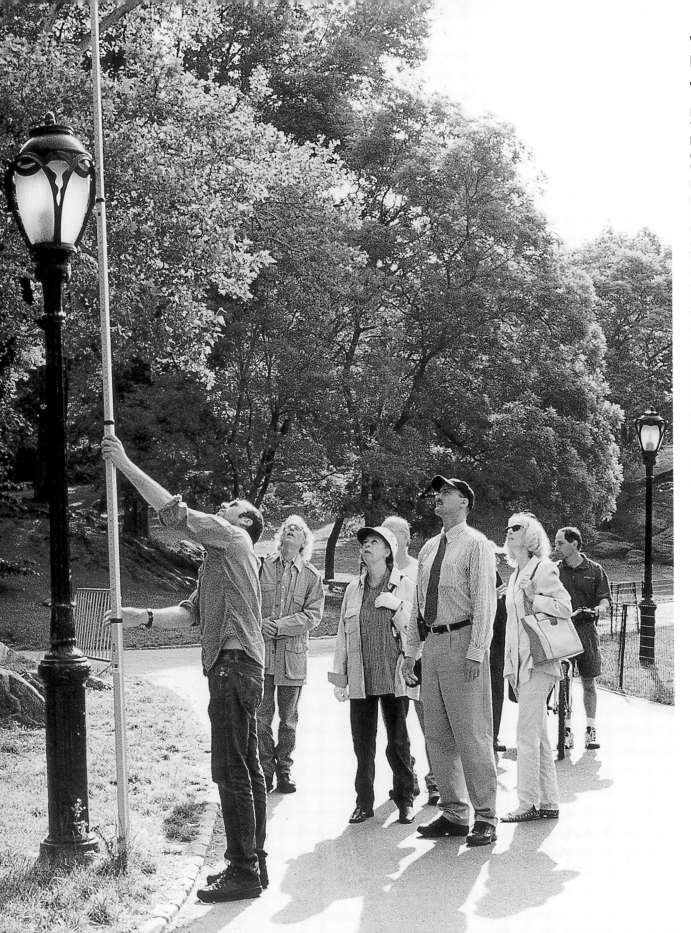

Working in Central Park, June 2002.

From left to right : Vladimir Yavachev measuring the height of a low branch, Christo, Jeanne-Claude, Vince Davenport, Douglas Blonsky (Central Park Administrator), Linda Silverman (The Gates Coordinator) and Adam Kaufman (Central Park Director of Night and Weekend Operations).

Part of the working family :
- Simon Chaput created and headed the office in Paris for The Pont Neuf Wrapped, and was in charge of the "Monitors" in Paris, in Japan 1991, and in Berlin 1995. He has worked at all the projects since 1985.
- Jonita Davenport created and headed the office in California for The Umbrellas, and has worked at every project since 1991. Two of her photographs in this book were shot during Wolfgang Volz's absence.
- Vince Davenport is Director of Construction / Engineer for The Gates and Over The River. He installed the yellow Umbrellas in California in 1991, and worked at the Wrapped Reichstag, 1995 and the Wrapped Trees 1998.

On the map provided by the Central Park Administrator, the hands of Vince Davenport and Christo while they are marking the location of some of the 7,400 Gates. This work took three weeks of walking 100 miles (161 kilometers).

Below : from left to right : Vladimir measuring the width of the walkway, Sylvia Volz, Simon Chaput, Masa Yanagi with the distance recording wheel, Jeanne-Claude, Vince and Christo marking on the map and Jonita Davenport holding the measuring tape.

Part of the working family :

- Sylvia Volz, photographer, wife and assistant of Wolfgang Volz who took all the photos in this book except two, and is the exclusive photographer of all the projects since 1971, he was the Project Director (with Roland Specker) for the Wrapped Reichstag, and Project Manager (with Josy Kraft) for the Wrapped Trees, and the Director for the Wall of 13,000 Oil Barrels.

- Masa Yanagi, art historian who wrote numerous texts in books and catalogues about the Christos' works, he was the liaison between New York-California-Japan for The Umbrellas.

- Vladimir Yvachev has worked at all the projects since 1991. He is the son of Christo's elder brother Anani.

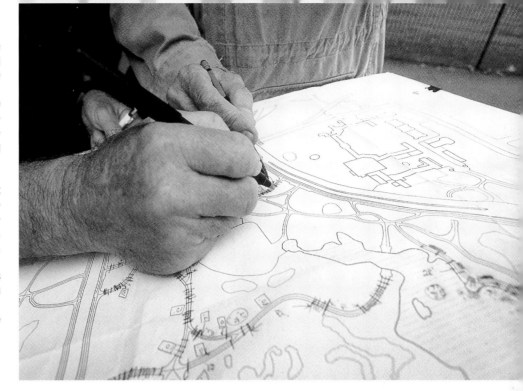

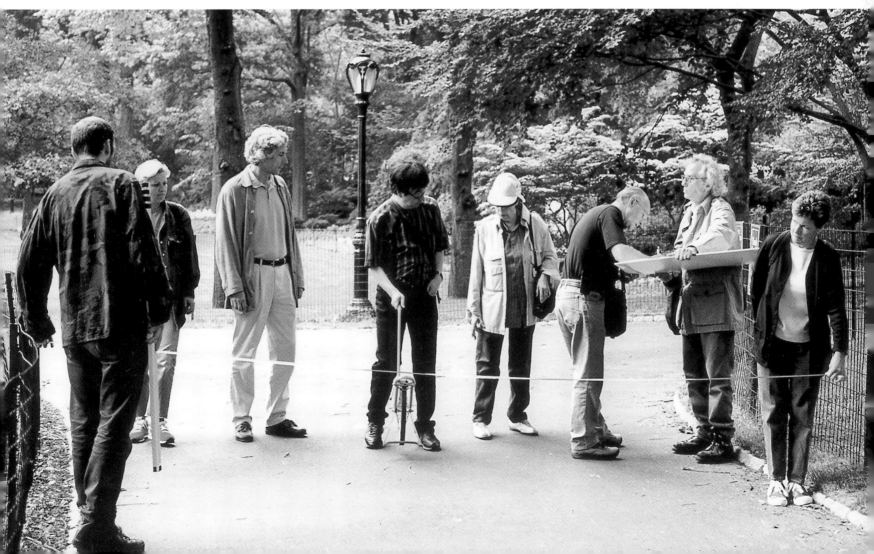

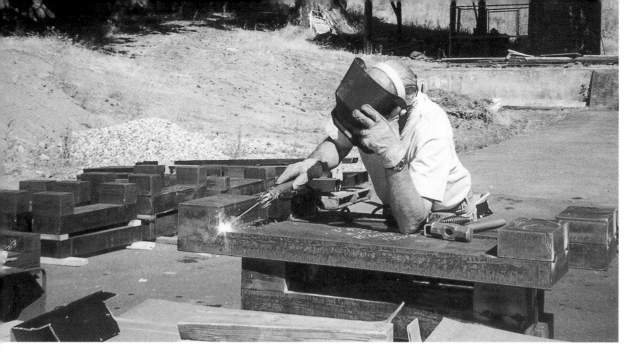

At his property in Leavenworth in the State of Washington, in preparation of the life-size test of September 2002, Vince Davenport is welding steel feet to a 408 kilogram (900 pound) steel base for additional weight and to provide clearance for attaching from underneath the pivotal bolt nut.
Photo : Jonita Davenport.

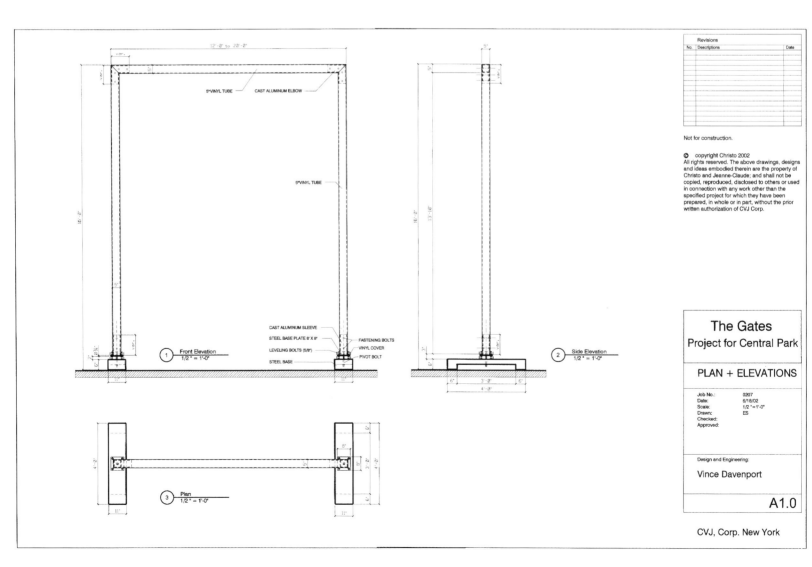

5"VINYL TUBE CAST ALUMINUM ELBOW

5"VINYL TUBE

CAST ALUMINUM SLEEVE
STEEL BASE PLATE 8" X 8"
LEVELING BOLTS (5/8")
STEEL BASE

FASTENING BOLTS
VINYL COVER
PIVOT BOLT

1 Front Elevation
 1/2" = 1'-0"

2 Side Elevation
 1/2" = 1'-0"

3 Plan
 1/2" = 1'-0"

Revisions		
No.	Descriptions	Date

The Gates
Project for Central Park

PLAN + ELEVATIONS

Job No.:	0207
Date:	6/18/02
Scale:	1/2" = 1'-0"
Drawn:	ES
Checked:	
Approved:	

Design and Engineering:

Vince Davenport

A1.0

CVJ, Corp. New York

Vince is drilling holes into the steel base to receive the 20 cm. (8 inch) long pivotal bolt used to secure the leveling plate on which the cast aluminum sleeves will be bolted.

The 4,8 meter long (16 feet), extruded in the same color as the saffron fabric, and recyclable Vinyl vertical pole, 12,7 cm. square (5 inch), will be secured, by fastening bolts to the cast aluminum sleeve.

Photo : Jonita Davenport.

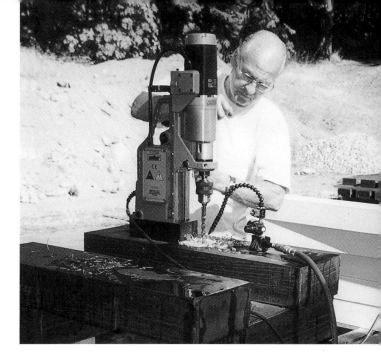

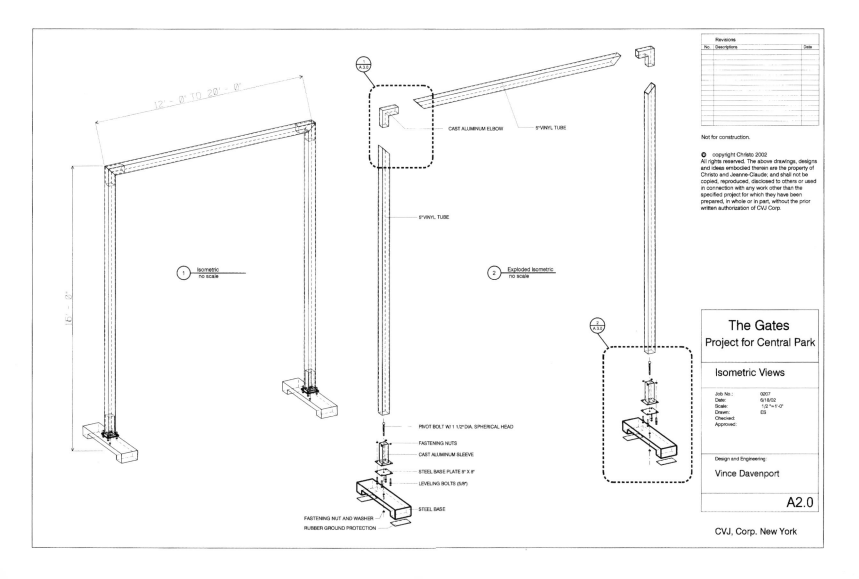

12' - 0" TO 20' - 0"

16' - 0"

1 Isometric
no scale

CAST ALUMINUM ELBOW

5"VINYL TUBE

5"VINYL TUBE

2 Exploded Isometric
no scale

PIVOT BOLT W/ 1 1/2"DIA. SPHERICAL HEAD

FASTENING NUTS

CAST ALUMINUM SLEEVE

STEEL BASE PLATE 8" X 8"

LEVELING BOLTS (5/8")

STEEL BASE

FASTENING NUT AND WASHER

RUBBER GROUND PROTECTION

Revisions		
No.	Descriptions	Date

Not for construction.

The Gates
Project for Central Park

Isometric Views

Job No.:	0207
Date:	6/18/02
Scale:	1/2 "=1'-0"
Drawn:	ES
Checked:	
Approved:	

Design and Engineering:

Vince Davenport

A2.0

CVJ, Corp. New York

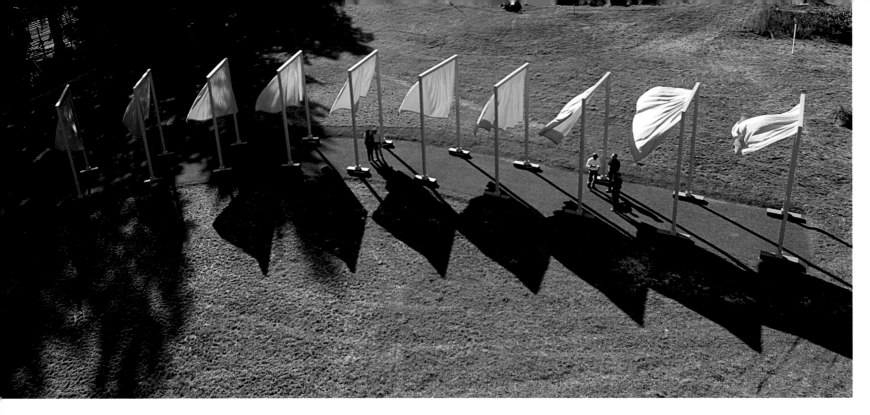

22 years later after the first tests, the 4th life-size test was conducted in September 2002 in Leavenworth, State of Washington, on the Davenport's private property.
The working team included Vince and Jonita Davenport, Doyle Davenport, Simon Chaput, Josy Kraft, Wolfgang and Sylvia Volz, Masa Yanagi, Vladimir Yavachev, Tom Golden and his friend Jim Kidder, Christo and Jeanne-Claude.
A variety of steel bases for different widths of walkways, leveling plates, insert sleeves and elbow connections for the square vinyl poles and fabric panels with a choice of two different colors with various sewing configurations, were tested.

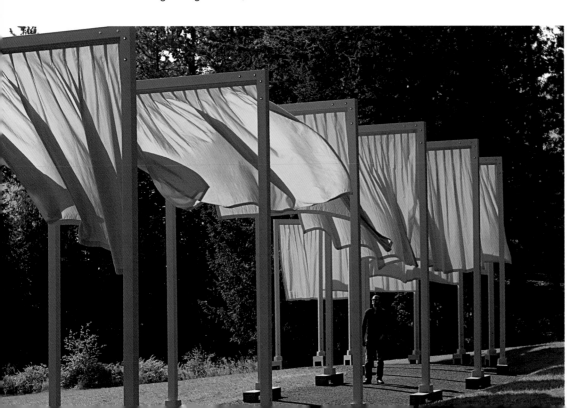

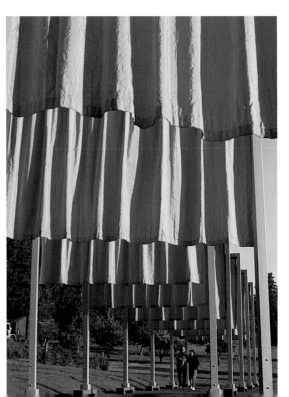

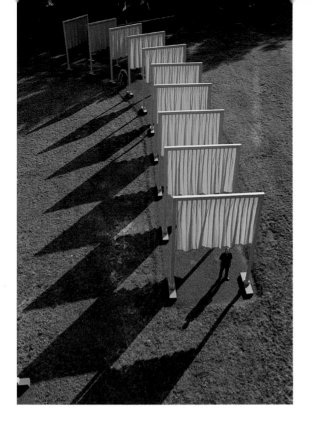

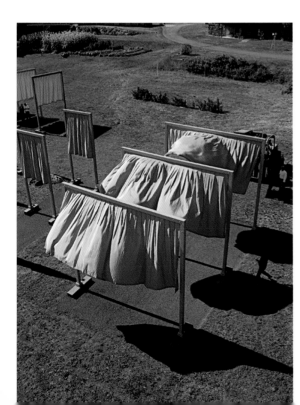

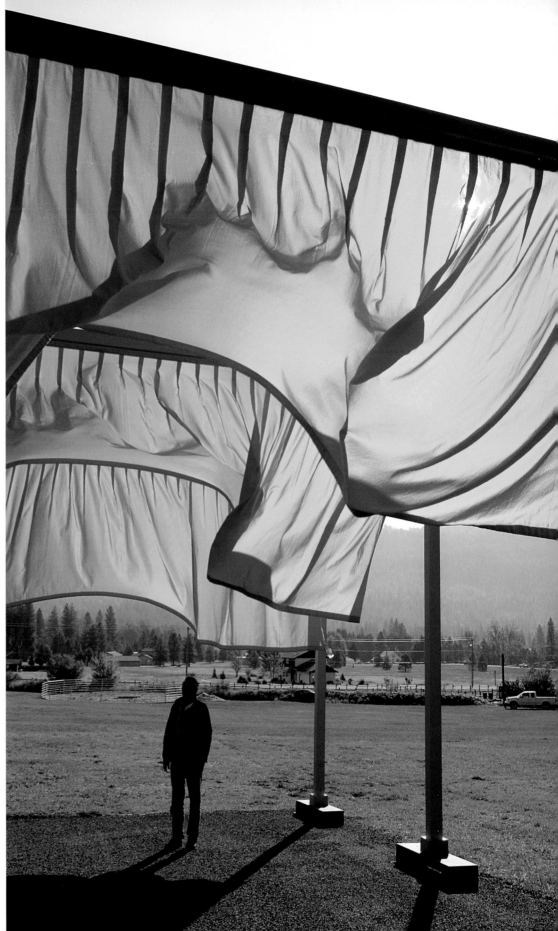

The cast aluminum elbow will connect the top of the vertical pole to the horizontal pole.
The leveling steel base plate, with the pivot bolt, will allow adjustment for the vertical alignment of the pole.
The steel base-weight between 408-635 kilograms (900-1,400 pounds), depending on the width of the walk-way, will be positioned on the pavement at the right and the left of the walkway.

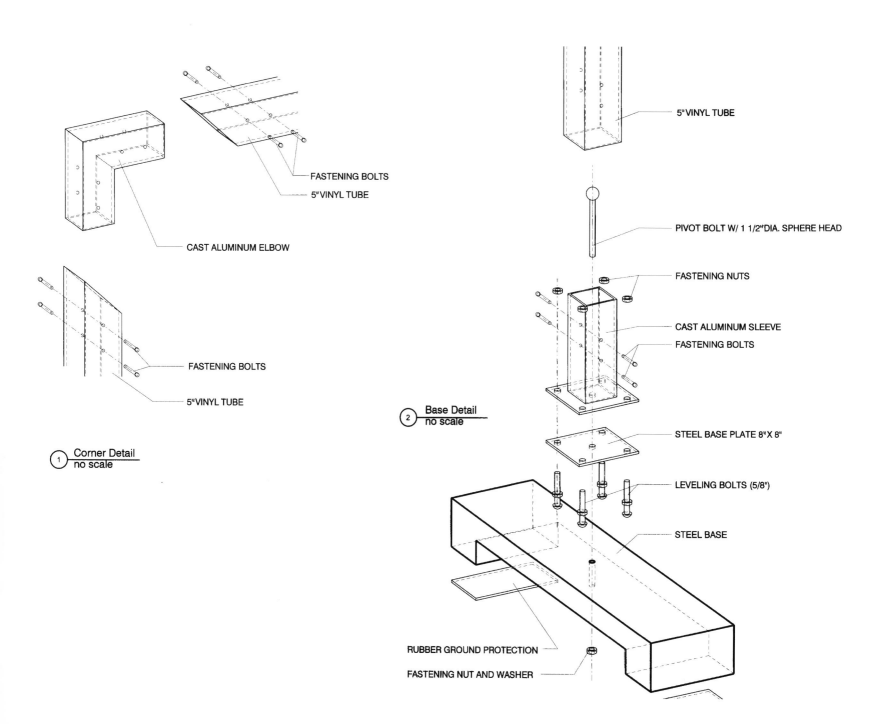

FASTENING BOLTS
5"VINYL TUBE

CAST ALUMINUM ELBOW

FASTENING BOLTS

5"VINYL TUBE

1 Corner Detail
 no scale

5"VINYL TUBE

PIVOT BOLT W/ 1 1/2"DIA. SPHERE HEAD

FASTENING NUTS

CAST ALUMINUM SLEEVE
FASTENING BOLTS

2 Base Detail
 no scale

STEEL BASE PLATE 8"X 8"

LEVELING BOLTS (5/8")

STEEL BASE

RUBBER GROUND PROTECTION

FASTENING NUT AND WASHER

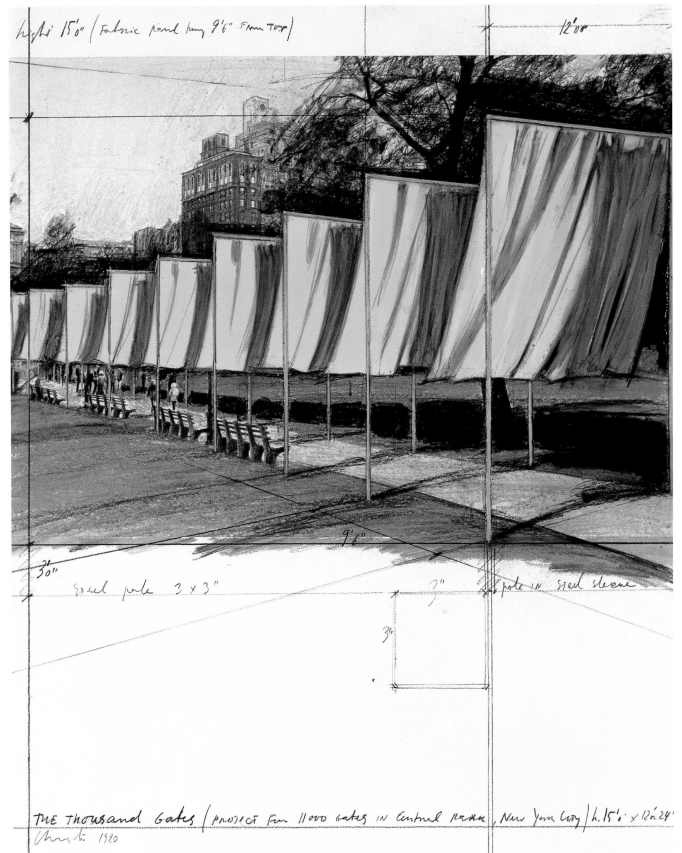

The Gates, Project for Central Park, New York City.
Collage 1980.
71 x 56 cm (28 x 22").
Pencil, fabric pastel, photograph by Wolfgang Volz, wax crayon and charcoal.

9'6"

12'

Christo 1980

15'0"

22½" print

1 Negative + 1 print

THE GATES, PROJECT FOR CENTRAL PARK, NEW YORK CITY.

 The Gates will be 15 feet high with a width varying from 9 to 24 feet
following the edges of the walkways in Central Park.
 Attached to the top of the steel Gates, perpendicularly to the walkways,
the fabric panels will hang freely, coming down to 5 feet six inches above
the ground, touching the heads of the average height visitors.
 The synthetic woven fabric panels will be 9 feet six inches long and
25% fuller than the width of the steel Gates.
 The steel Gates will follow each other at a 9 feet interval, all along
the walkways, allowing the colorful fabric panels to wave horizontally
towards the next Gate.

 Christo, New York, 1980.

THE GATES / PROJECT FOR CENTRAL PARK, New York City / Approx. 11.000 gates

The Gates, Project for
Central Park, New York.
Collage 1980.
35,5 x 28 cm (14 x 11").
Pencil, fabric, photograph
by Wolfgang Volz, charcoal,
ball point pen, text and tape.

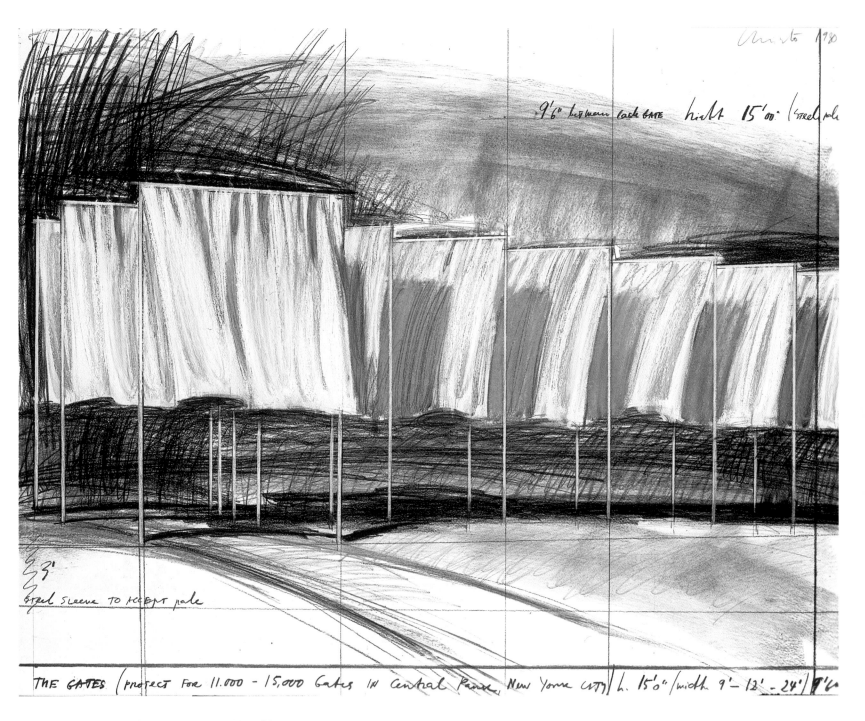

The Gates, Project for Central Park, New York City.
Drawing 1980.
56 x 71 cm (22 x 28").
Pencil, charcoal and pastel, photograph by Wolfgang Volz.

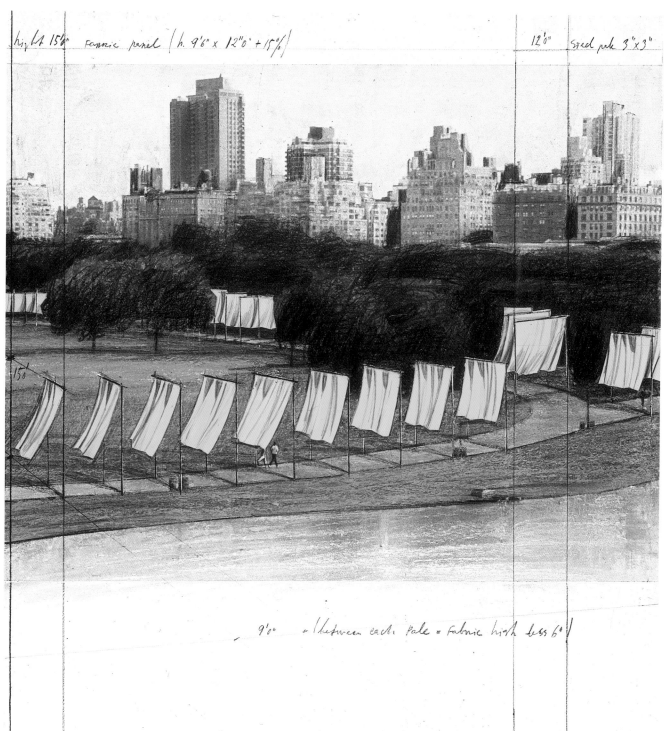

height 15'6" fabric panel (h. 9'6" x 12"0" + 15%)

12'0" steel pole 3"x3"

15'0"

9'0" = (between each pole = fabric high less 6")

THE Gates / Project for 11.000 Gates IN Central Park, New York City / hight 15'0" x 12'2" or 24' or 39'

Christo 1980

The Gates, Project for Central Park, New York City.
Collage 1980.
71 x 56 cm (28 x 22").
Pencil, fabric, pastel, photograph by Wolfgang Volz and charcoal.

The Gates, Project for Central Park, New York City.
Collage 1980.
In two parts:
28 x 71 cm and 56 x 71 cm (11 x 28" and 22 x 28").
Pencil, fabric, pastel, charcoal, crayon and map.

Christo 1980

Rectangular Frame of steel Tube 2"x2"⅛" painted

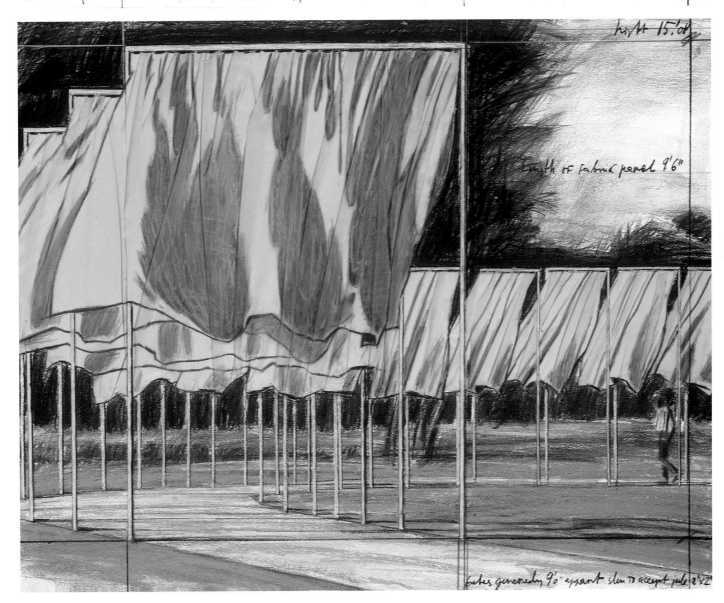

THE GATES (PROJECT FOR CENTRAL PARK, NEW YORK CITY) 11.000 - 15.000 Gates height 15'0" width from 9'0" to 27'0" along selected walkways

hight 15'0"

Length of fabric panel 9'6"

Gates generally 9'0" apart slam to accept pole 3'x2"

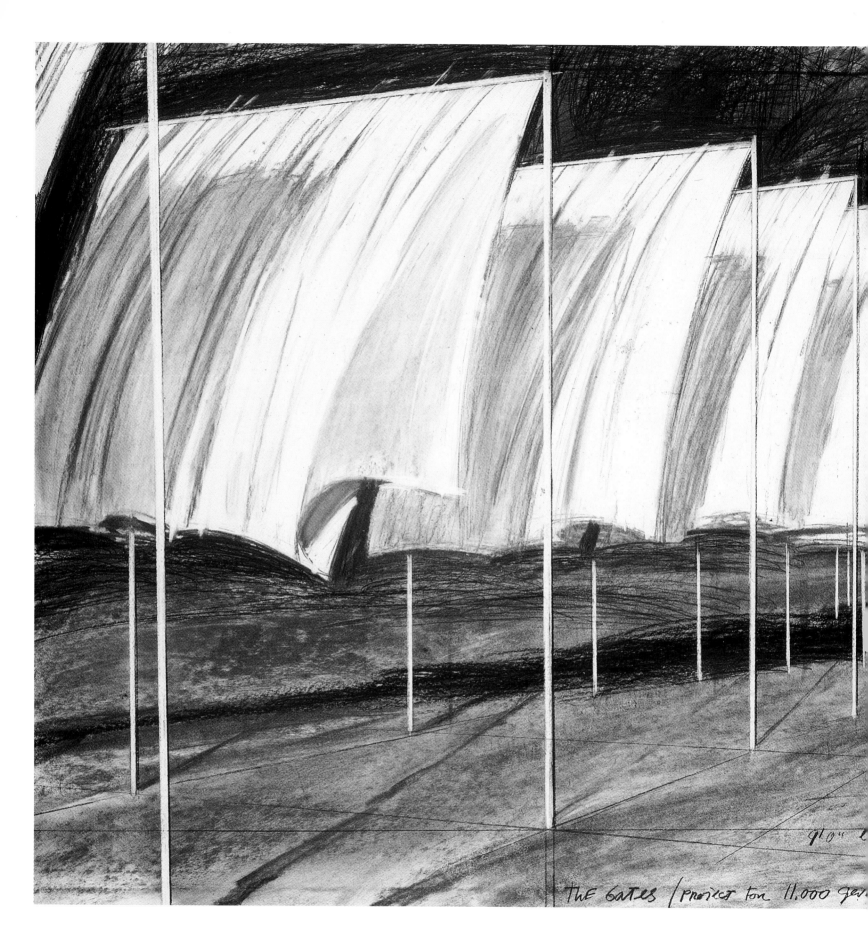

THE GATES / PROJECT FOR 11.000 g...

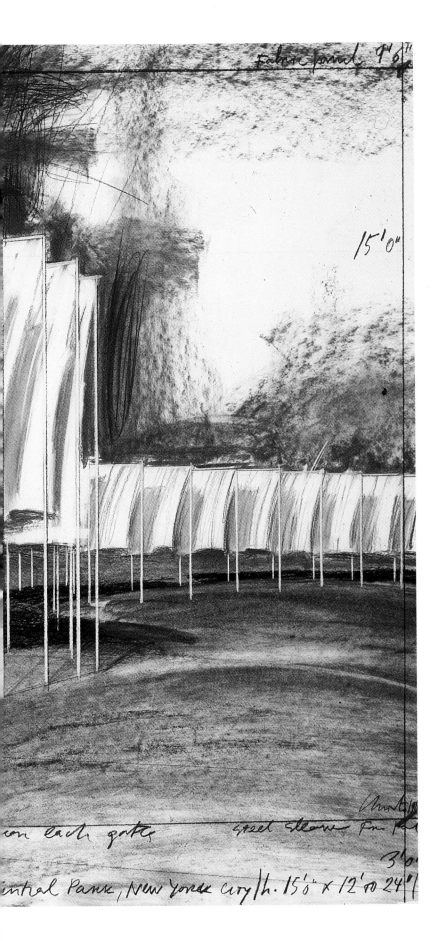

The Gates, Project for Central Park, New York City.
Drawing 1980.
106,6 x 165 cm (42 x 65").
Pencil and charcoal.

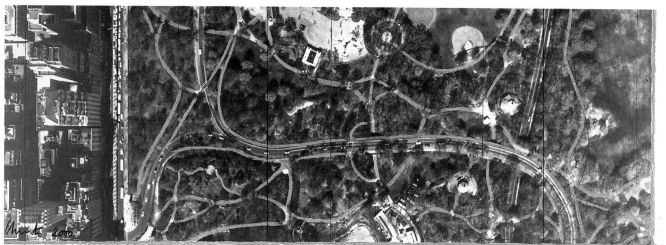

The Gates, Project for Central Park, New York City. Collage 2000. In two parts: 30,5 x 77,5 cm and 66,7 x 77,5 cm. (12 x 30.1/2" and 26.1/4" x 30.1/2"). Pencil, fabric, wax crayon, charcoal, pastel and aerial photograph.

The Gates (project for Central Park, New York City) Central Park So., 5th Ave., Central Park W., Cathedral Pkwy, W 110 St.

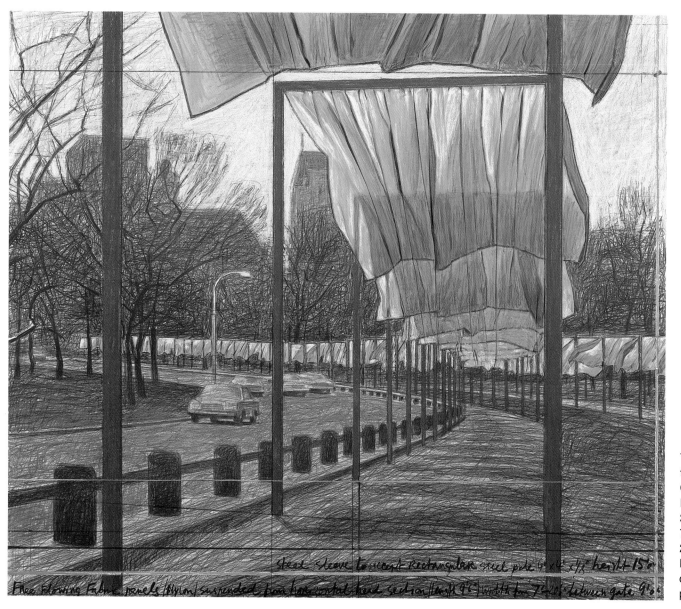

The Gates, Project for Central Park, New York City. Collage 2002. In two parts: 30,5 x 77,5 cm and 66,7 x 77,5 cm. (12 x 30.1/2" and 26.1/4" x 30.1/2"). Pencil, fabric, wax crayon, charcoal, pastel, enamel paint and map.

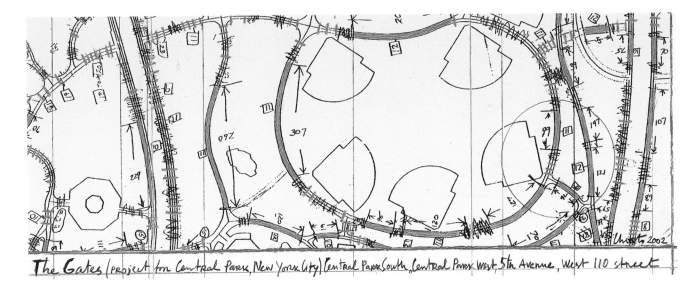

The Gates (project for Central Park, New York City) Central Park South, Central Park West, 5th Avenue, West 110 street

Free Flowing Fabric panels (nylon cloth) suspended from horizontal head section (length 8'6") width of gate from 6'0" to 20'0"

cast aluminum elbow with fastening bolts between each gate approximately 10'0"-12'0" height 16'0"

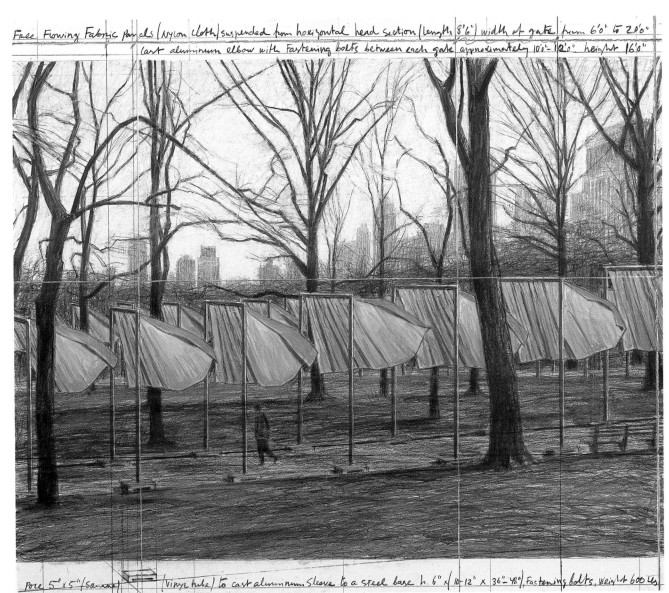

Pole 5"x5" (square) (vinyl tube) to cast aluminum sleeve to a steel base h. 6" x (10-12" x 36"-48"), fastening bolts, weight 600 Lbs

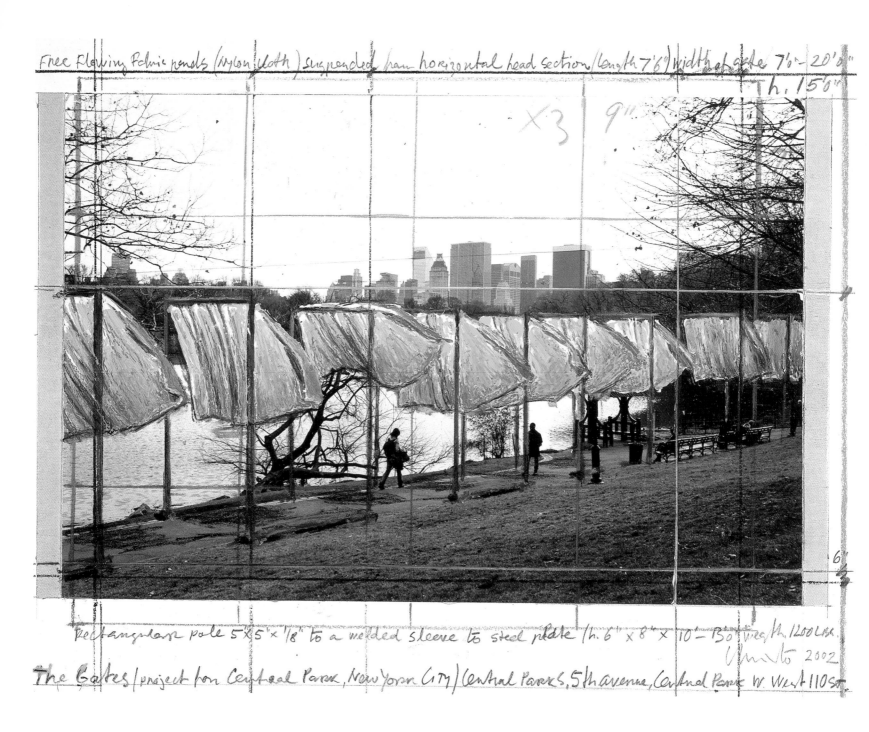

The Gates, Project for Central Park, New York City.
Collage 2002.
21,5 x 28 cm (8 1/2 x 11").
Pencil, enamel paint, photograph by Wolfgang Volz,
wax crayon and tape.

The Gates, Project for Central Park, New York City.
Drawing 1996.
In two parts:
244 x 106 cm and 244 x 38 cm
(96 x 42" and 96 x 15").
Pencil, charcoal, pastel, wax crayon, photograph by
Wolfgang Volz and aerial photographic map.

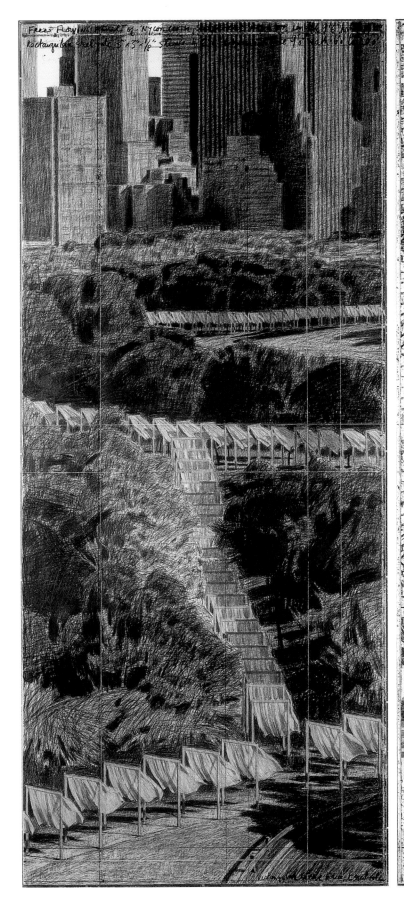

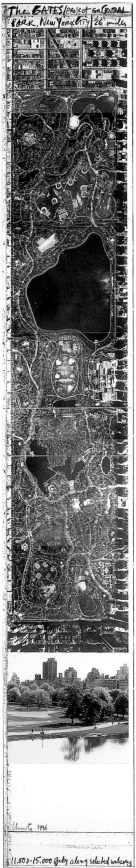

The Gates, Project for Central Park, New York City.
Drawing 2001.
In two parts :
38 x 244 cm and 106,6 x 244 cm
(15 x 96" and 42 x 96").
Pencil, charcoal, pastel, wax crayon and aerial
photograph.

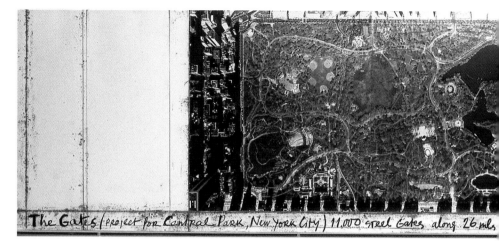

The Gates (project for Central Park, New York City) 11,000 steel Gates along 26 mls

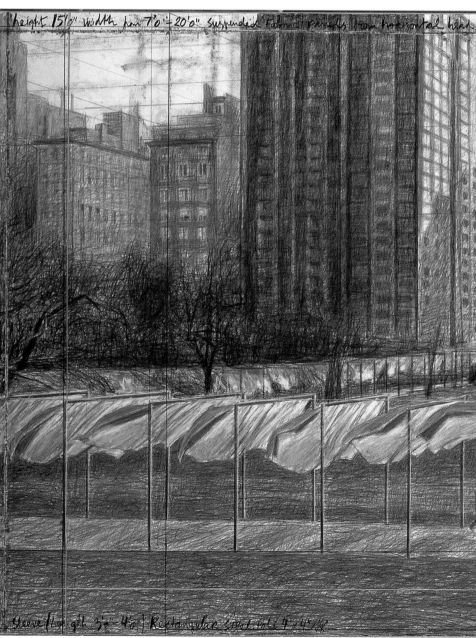

height 15'0" Width from 7'0" ÷ 20'0" suspended Fabric Panels from horizontal head

Sleeve Length 3'0 ÷ 4'0 / Rectangular steel pole 4" x 4"x/8

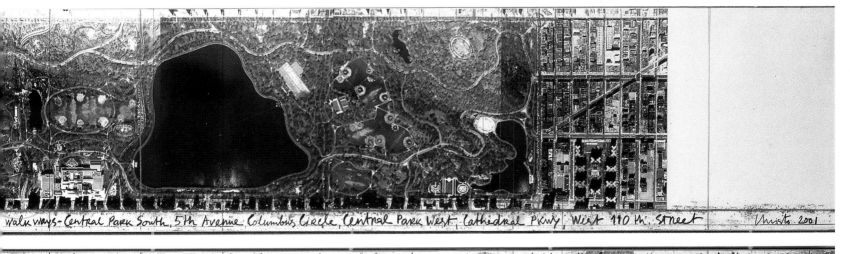

walkways - Central Park South, 5th Avenue, Columbus Circle, Central Park West, Cathedral Pkwy, West 110 th Street Christo. 2001

length 9'6") between each gate approximately 9'0"-10'0" the Fabric panel - Nylon cloth attached with special bolts to steel pole

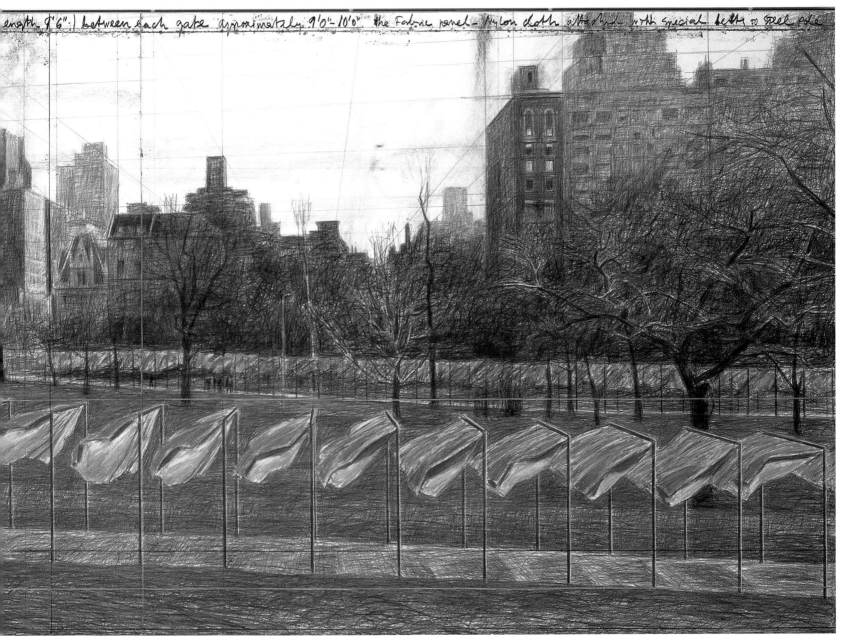

The Gates, Project for Central Park, New York City.
Collage 1999.
21,5 x 28 cm (8 1/2 x 11").
Pencil, enamel paint, photograph by Wolfgang
Volz,wax crayon and tape.

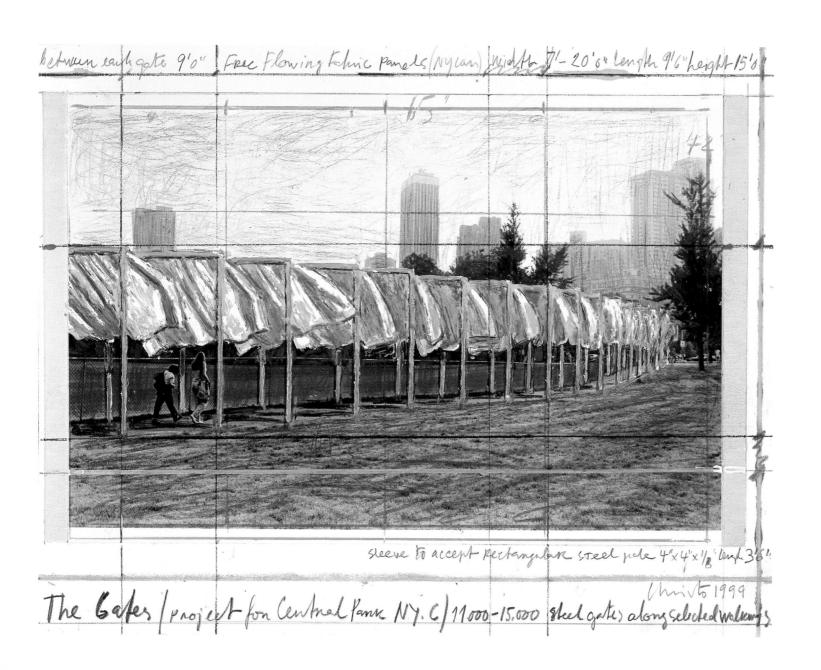

The Gates, Project for Central
Park, New York City.
Collage 1999.
In two parts : 30,5 x 77,5 cm
and 66,7 x 77,5 cm
(12 x 30 1/2" and 26 1/4 x 30
1/2").
Pencil, fabric, pastel,
charcoal, wax crayon and
aerial photograph.

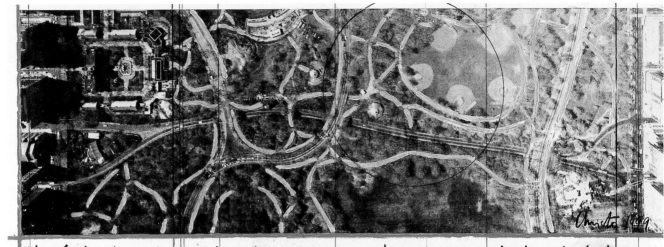

The Gates / project for Central Park, New York CITY / 11.000 - 15.000 steel gates along selected walkways

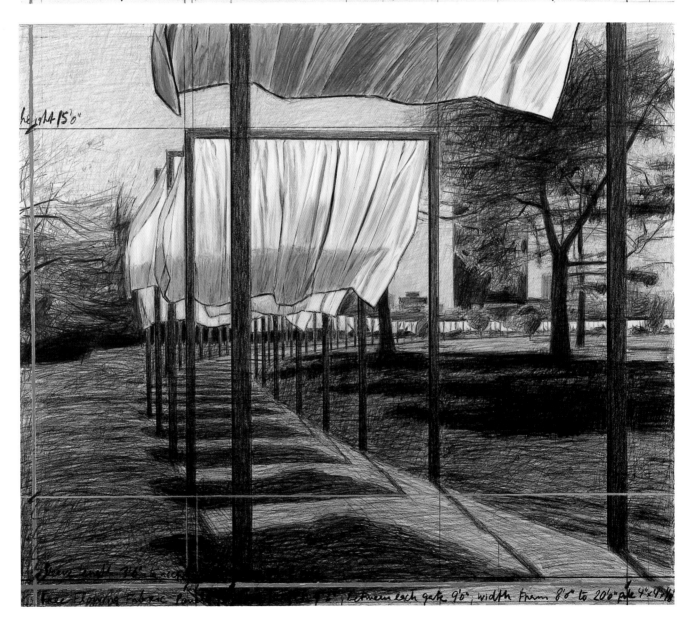

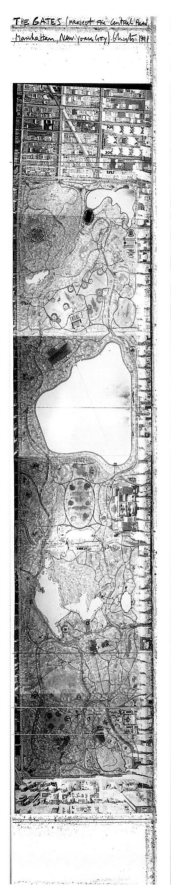

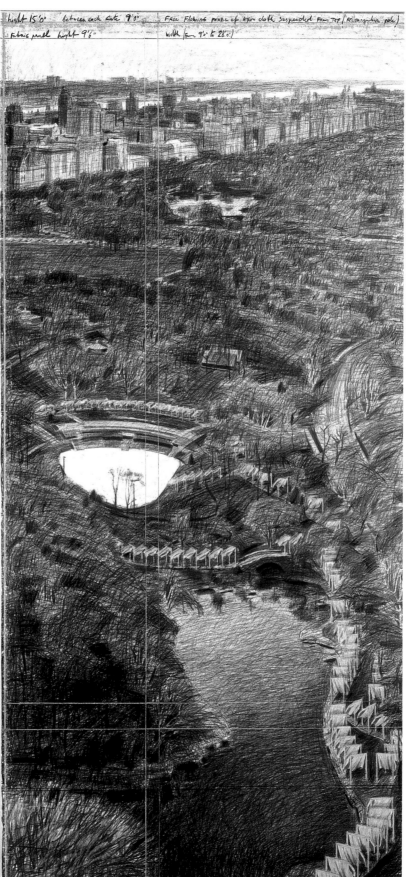

The Gates, Project for Central Park,
New York.
Drawing 1991.
In two parts :
203,6 x 38 cm and 203,6 x 106,6 cm
(86 1/2 x 15" and 86 1/2 x 42").
Pencil, charcoal, crayon, pastel and
aerial photograph.

The Gates, Project for Central Park,
New York.
Drawing 1991.
In two parts :
203,6 x 38 cm and 203,6 x 106,6 cm
(86 1/2 x 15" and 86 1/2 x 42").
Pencil, charcoal, pastel, crayon and
map.

THE GATES (PROJECT FOR Central PARK, New York CITY) Christo 1991

height Fabric panel height 9'6" width 12'0" (From 9'0" to 28'0") Free Flowing Panel of Nylon cloth suspended from top
15'0" 9'6" between each Gates

75 11,000-15,000 GATES along selected walk ways steel pole 2½" x ¼" (show Edge of walk ways)

The Gates, Project for Central Park, New York City.
Drawing 1986.
In two parts :
38 x 244 cm and 106,6 x 244 cm (15 x 96" and 42 x 96").
Pencil, charcoal, pastel, wax crayon and map.

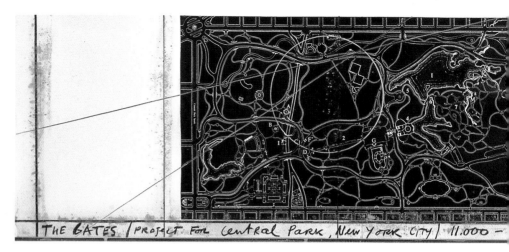

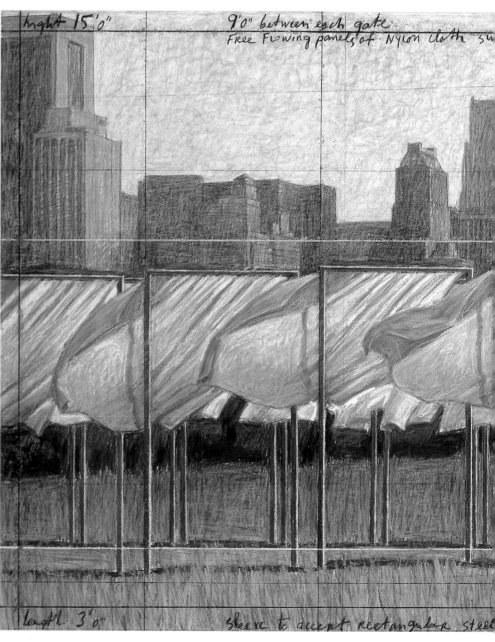

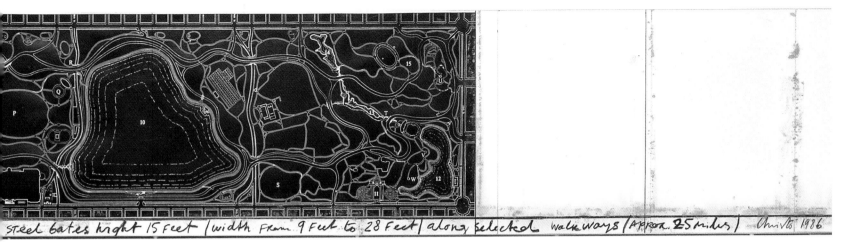

steel Gates hight 15 Feet / width From 9 Feet to 28 Feet / along Selected walk ways (Approx. 25 miles) Christo 1986

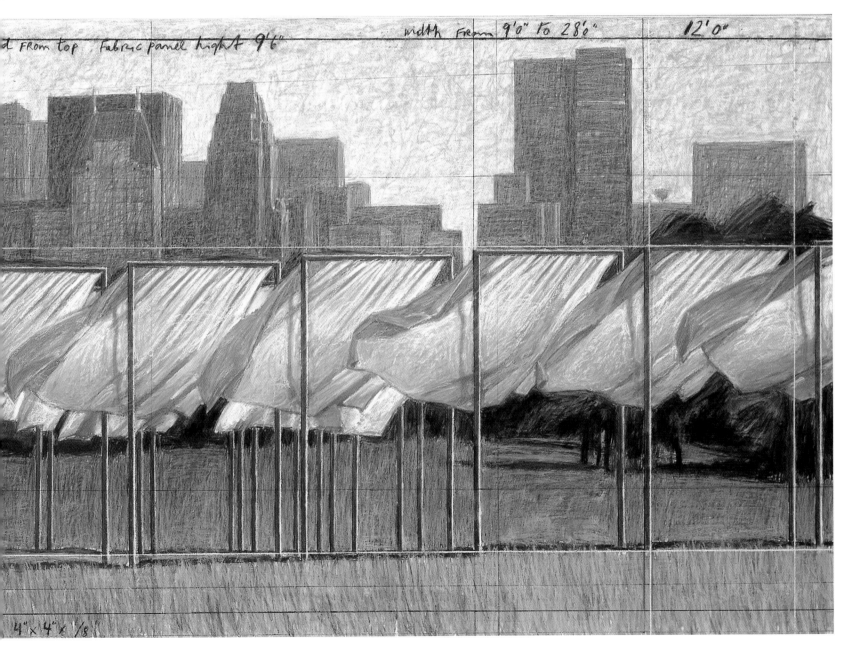

d FROM top Fabric panel hight 9'6" width From 9'0" to 28'0" 12'0"

4"x4"x1/8"

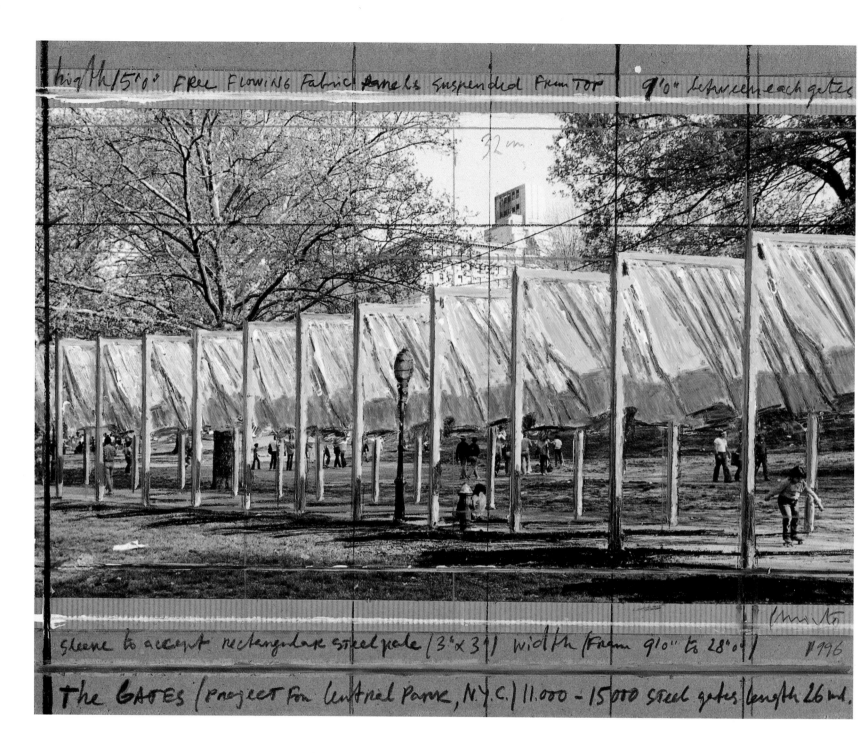

The Gates, Project for Central Park, New York City.
Collage 1996.
28 x 35,5 cm (11 x 14").
Pencil, enamel paint, photograph by Wolfgang Volz,
wax crayon, charcoal, tape, on brown cardboard.

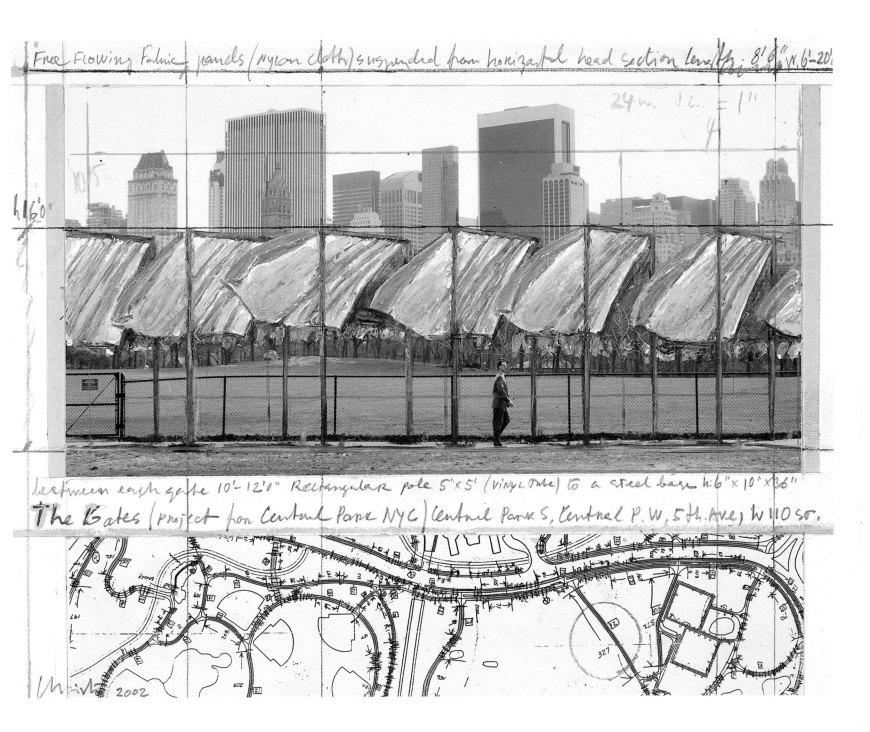

The Gates, Project for Central Park, New York City.
Collage 2002.
21,5 x 28 cm (8 1/2 x 11").
Pencil, enamel paint, photograph by Wolfgang Volz,
wax crayon, map and tape.

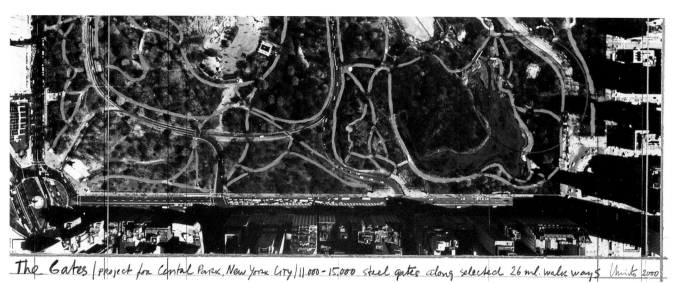

The Gates, Project for Central Park, New York City. Collage 2000.
In two parts :
30,5 x 77,5 cm and 66,7 x 77,5 cm (12 x 30 1/2" and 26 1/4 x 30 1/2").
Pencil, fabric, wax crayon, charcoal, pastel and aerial, photograph.

The Gates / project for Central Park, New York City / 11.000 - 15.000 steel gates along selected 26 ml. walk ways | Christo 2000

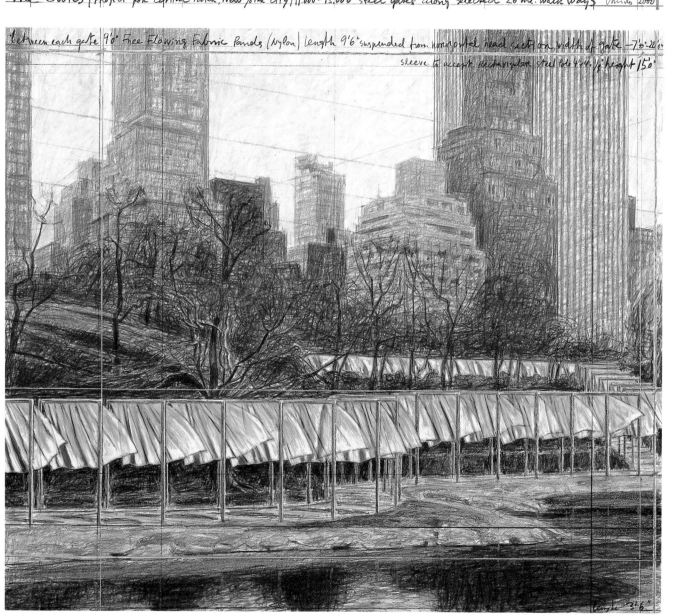

between each gate 9'6" Free Flowing Fabric Panels (Nylon) length 9'6" suspended from horizontal read section width of gate – 7'8"-26'6"
sleeve to accept rectangular steel pole 4x4. 1/8 height 15'0"

The Gates, Project for Central Park, New York City.
Collage 2002.
In two parts :
30,5 x 77,5 cm and 66,7 x
77,5 cm (12 x 30 1/2" and
26 1/4 x 30 1/2").
Pencil, fabric, wax crayon,
charcoal, pastel and aerial
photograph.

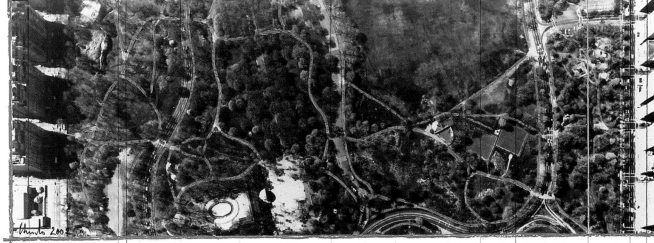

The Gates (Project for Central Park New York City) Central Park S., 5th. Avenue, Central Park West, Cathedral Pkwy, West 110 St.

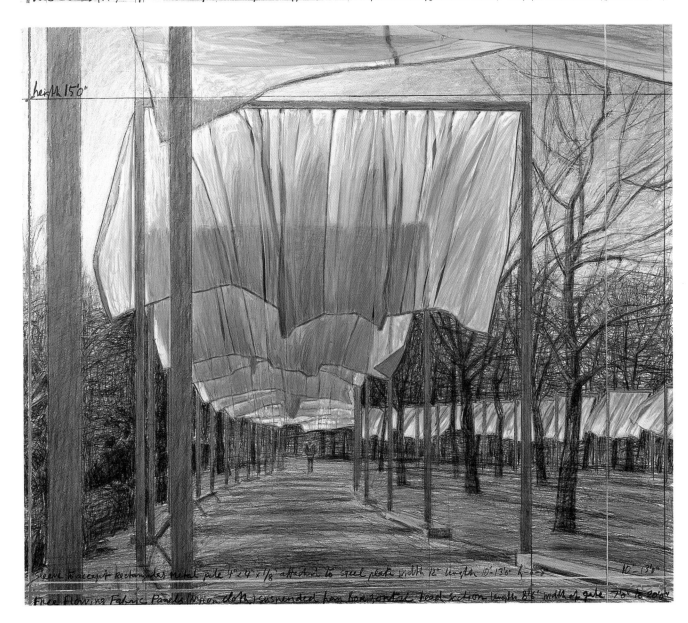

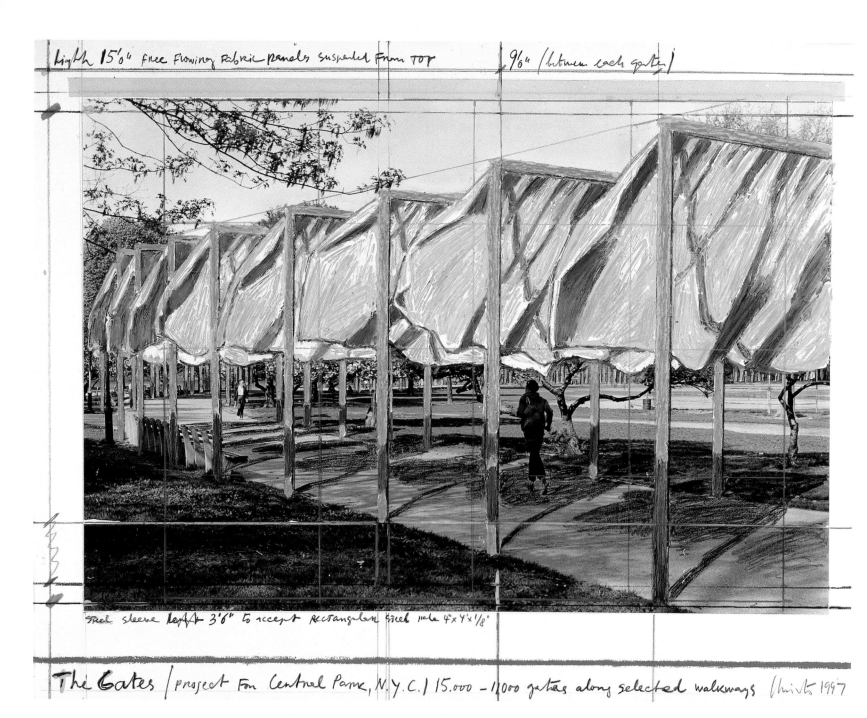

The Gates, Project for Central Park, New York City.
Collage 1997.
43,2 x 56 cm (17 x 22").
Pencil, enamel paint, photograph by Wolfgang Volz,
wax crayon and tape.

The Gates, Project for Central Park, New York City.
Drawing 2000.
38,7 x 35,2 cm (15 1/4 x 13 7/8").
Pencil, charcoal, pastel and wax crayon.

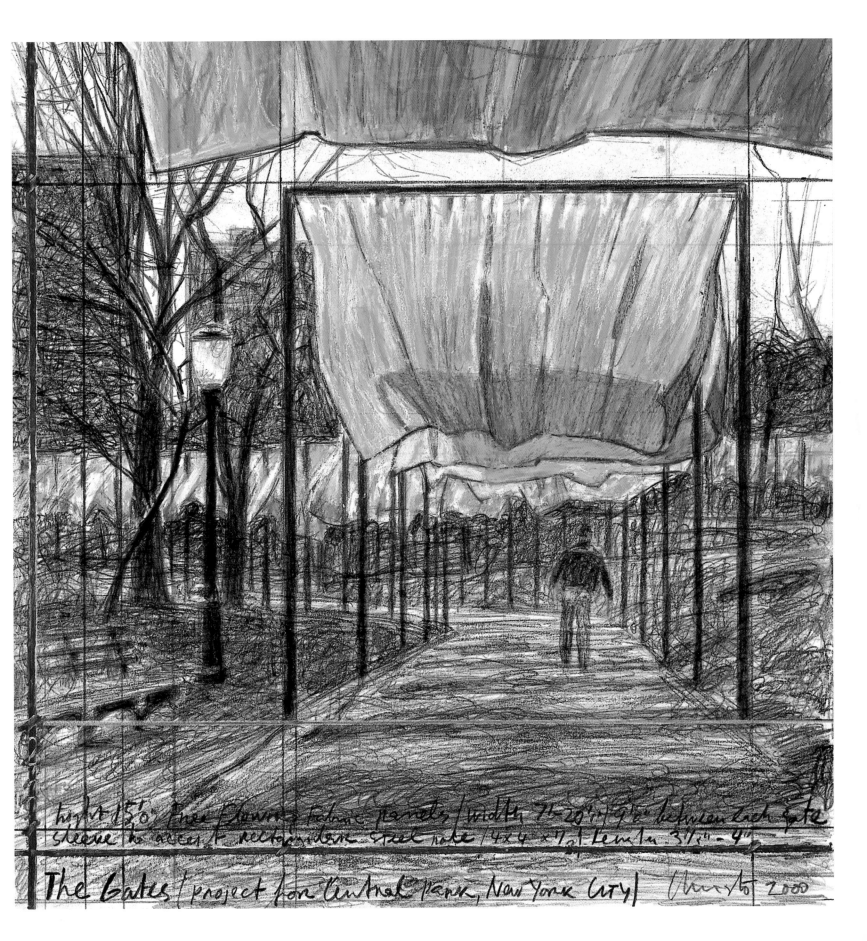

height 15'0" free flowing fabric panels / width 7½-20'in / 9'6" between each gate
sleeve to accept a rectangular steel pole / 4 x 4 x ? / length 3½" - 4"

The Gates / project for Central Park, New York City / Christo 2000

The Gates, Project for Central Park, New York City.
Collage 1999.
43,2 x 55,9 cm (17 x 22").
Pencil, enamel paint, photograph by Wolfgang Volz,
wax crayon and tape.

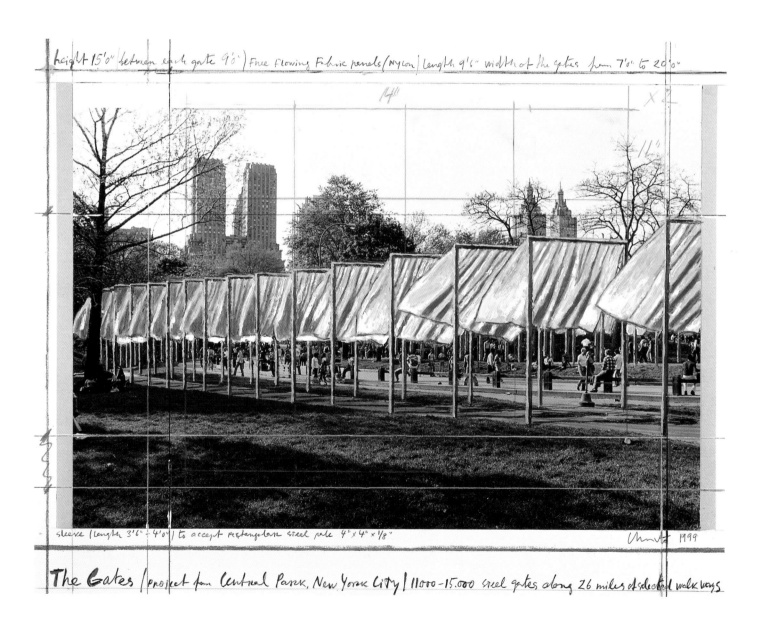

height 15'0" between each gate 9'0") Free Flowing Fabric panels (Nylon) Length 9'6" width of the gates from 7'0" to 20'0"

14"

11"

sleeve (length 3'6" + 4'0") to accept rectangular steel pole 4" x 4" x 1/8"

Christo 1999

The Gates (project for Central Park, New York City) 11000 - 15.000 steel gates along 26 miles of selected walk ways

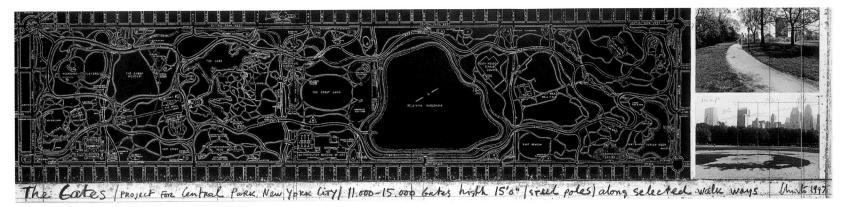

The Gates (Project for Central Park, New York City) 11.000-15.000 Gates high 15'0" (steel poles) along selected walk ways Christo 1997

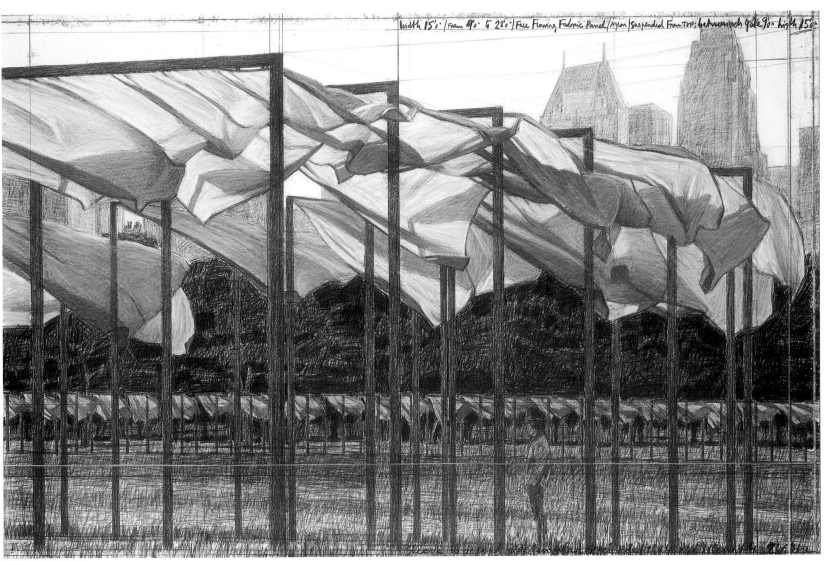

width 15'0" / From 9'0" to 28'0" / Free Flowing Fabric Panel (Nylon) suspended From Top; between each gate 9'0" high 15'

The Gates, Project for Central Park, New York City.
Drawing 1997.
In two parts :
38 x 165 cm and 106,6 x 165 cm (15 x 65" and 42 x 65").
Pencil, charcoal, photographs by Wolfgang Volz, wax crayon, pastel and map.

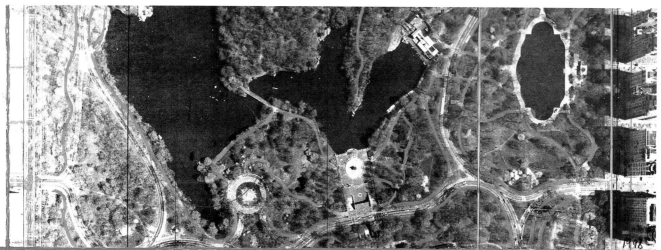

The Gates, Project for Central Park, New York City. Collage 1998 in 2 parts : 30,5 x 77,5 cm and 66,7 x 77,5 cm (12 x 30 1/2 and 26 1/4 x 30 1/2"). Pencil, pastel, wax crayon, fabric, aerial photograph and charcoal.

The Gates (Project for Central Park, New York City) 11,000 - 15,000 steel gates along selected walk ways / Christo

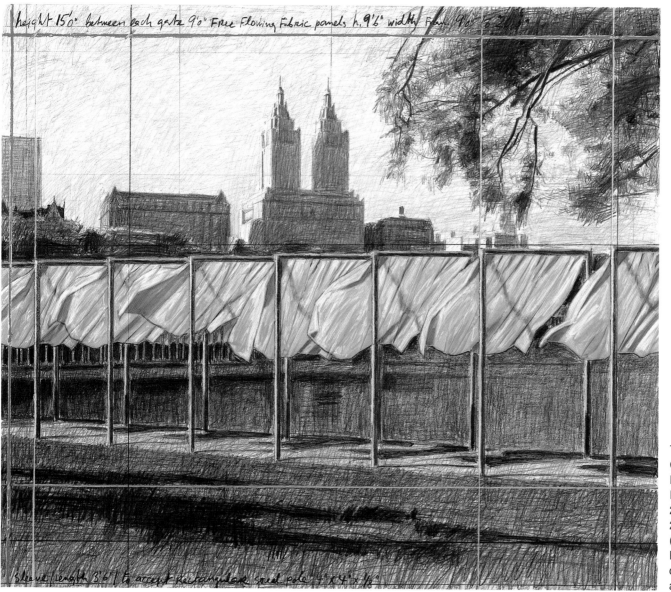

height 15'0" between each gate 9'0" Free Flowing Fabric panels h. 9'6" width from 9'0" to 28'0"

sleeve length 8'6" to accept rectangular steel pole 4" x 4" x 1/8"

The Gates, Project for Central Park, New York City. Drawing 2002. In two parts : 244 x 106,6 cm and 244 x 38 cm (96 x 42" and 96 x 15"). Pencil, charcoal, pastel, wax crayon, aerial photograph and technical data.

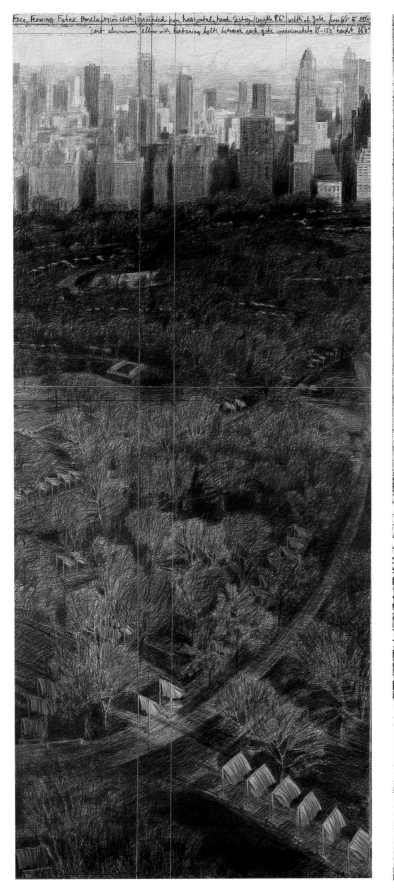
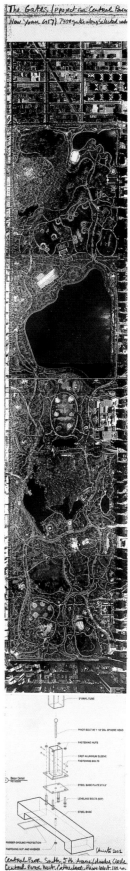

The Gates, Project for Central Park, New York City.
Drawing 2001.
In two parts:
38 x 165 cm and 106,6 x 165 cm. (15 x 65" and 42 x 65").
Pencil, charcoal, pastel, wax crayon and aerial photograph.

The Gates, Project for Central Park, New York City.
Drawing 2001.
In two parts : 38 x 165 cm and 106,6 x 165 cm
(15 x 65" and 42 x 65").
Pencil, pastel, charcoal, wax crayon and aerial photograph.

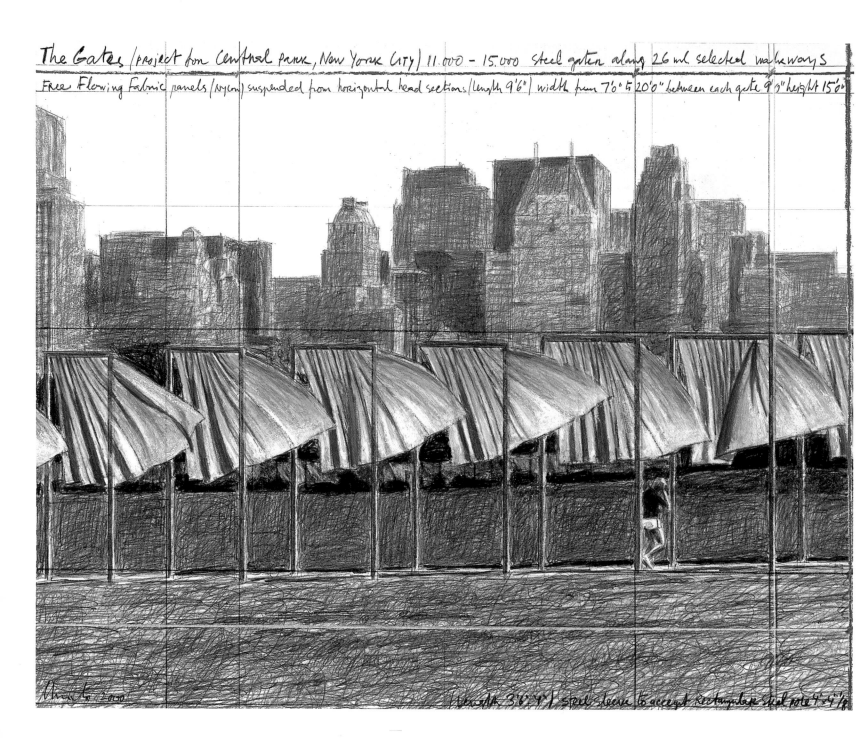

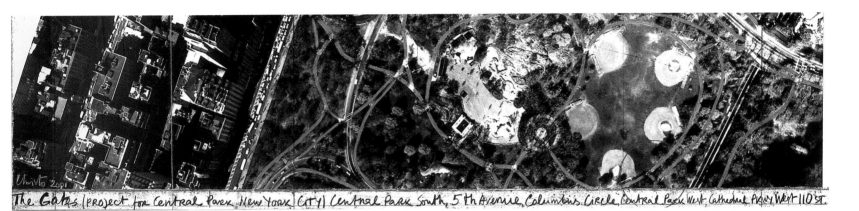

Christo 2001

The Gates (Project for Central Park, New York City) Central Park South, 5th Avenue, Columbus Circle, Central Park West Cathedral Pkwy West 110 St.

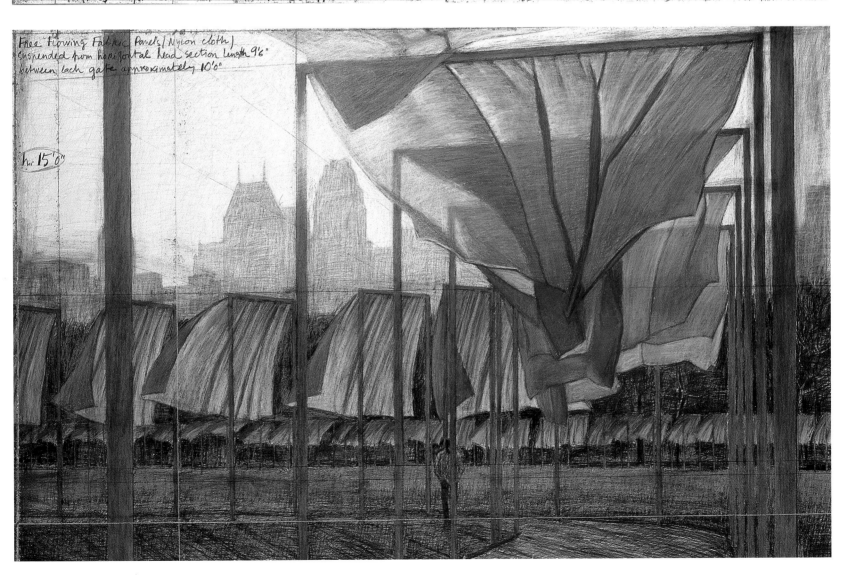

Free Flowing Fabric Panels (Nylon cloth)
Suspended from horizontal head section length 9'6"
between each gate approximately 10'0"

h. 15'0"

The Gates, Project for Central Park, New York City.
Collage 1998.
21,5 x 28 cm (8 1/2 x 11").
Pencil, enamel paint, photograph by Wolfgang Volz,
wax crayon and tape on brown cadboard.

The Gates, Project for Central Park, New York City.
Drawing 1996.
In two parts :
165 x 106,6 and 165 x 38 cm
(65 x 42" and 65 x 15").
Pencil, charcoal, pastel, wax crayon and aerial photograph.

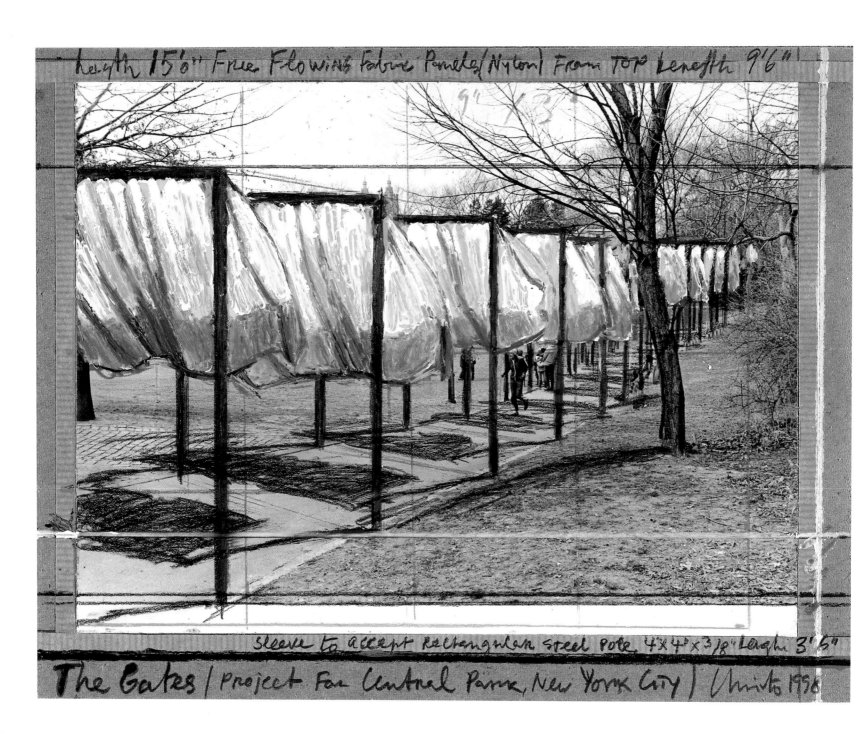

between each gate 9'0" free flowing fabric panels, suspended from top / width 9' to 20'0" / high 15'0"

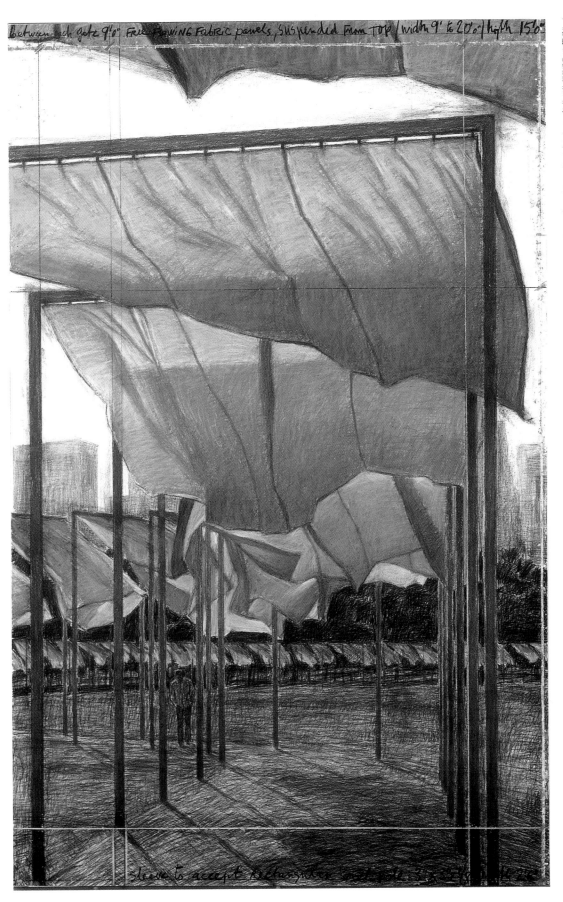

The Gates / project for Central Park.

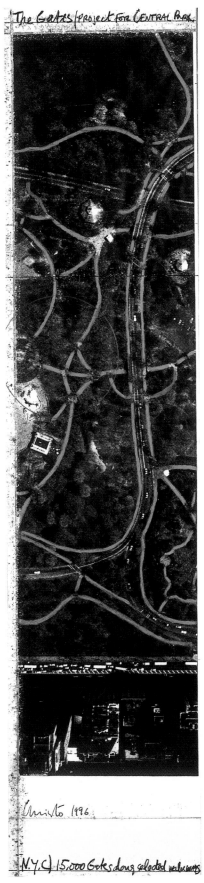

Christo 1996

N.Y.C | 15,000 Gates along selected walkways

sleeve to accept Aluminum extrusion 3" × 3/8"

91

The Gates, Project for Central Park, New York City.
Collage 1996.
33,5 x 56 cm (14 x 22").
Pencil, enamel paint, photograph by Wolfgang Volz,
wax crayon and tape.

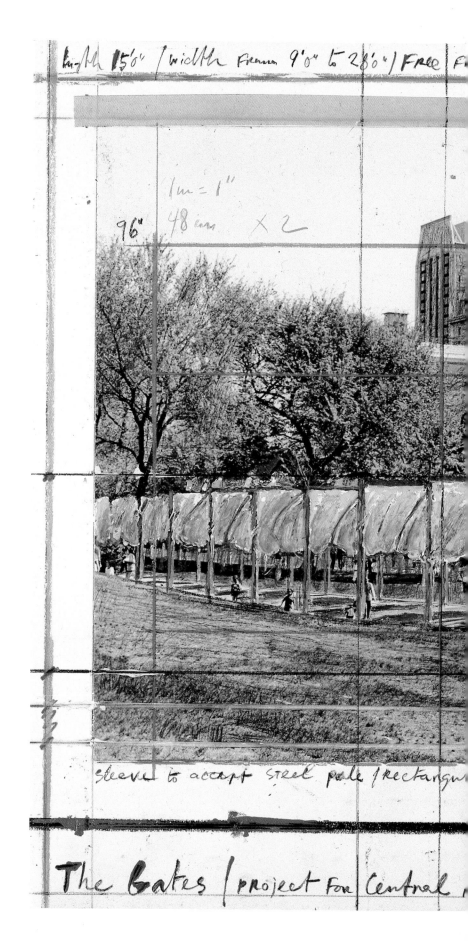

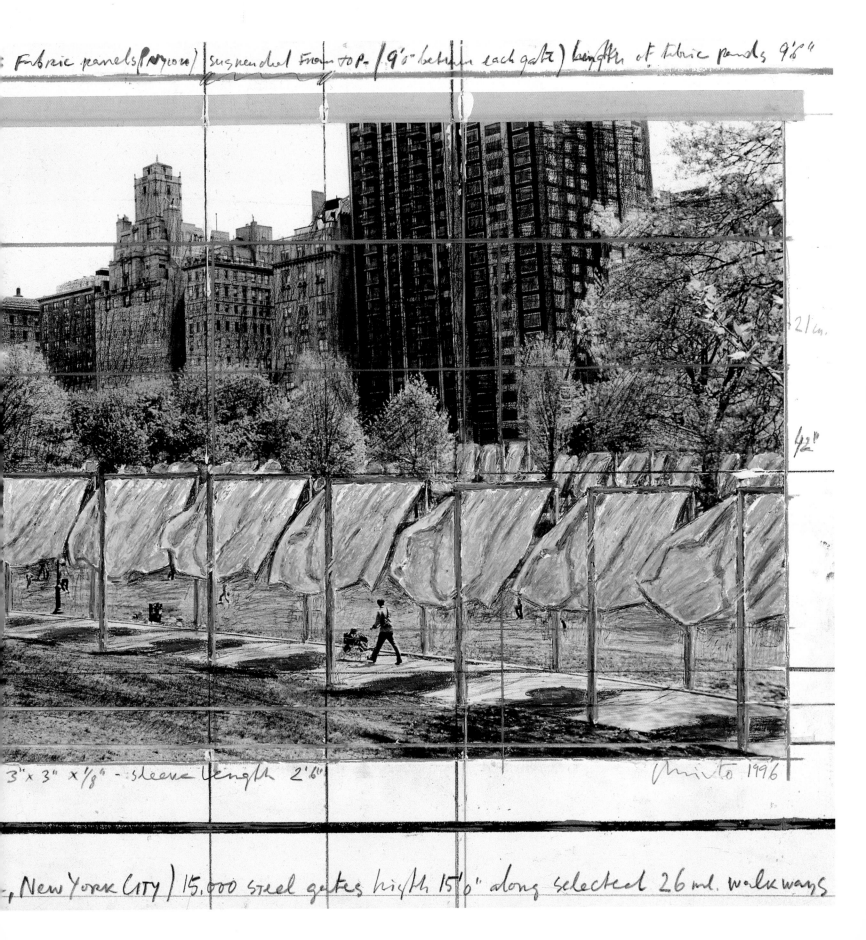

Fabric panels (Nylon) suspended from top. (9'0" between each gate) length of fabric panels 9'6"

21 cm.

42"

3" x 3" x 1/8" - sleeve length 2'6" Christo 1996

, New York (ITY) 15.000 steel gates high 15'0" along selected 26 m. walkways

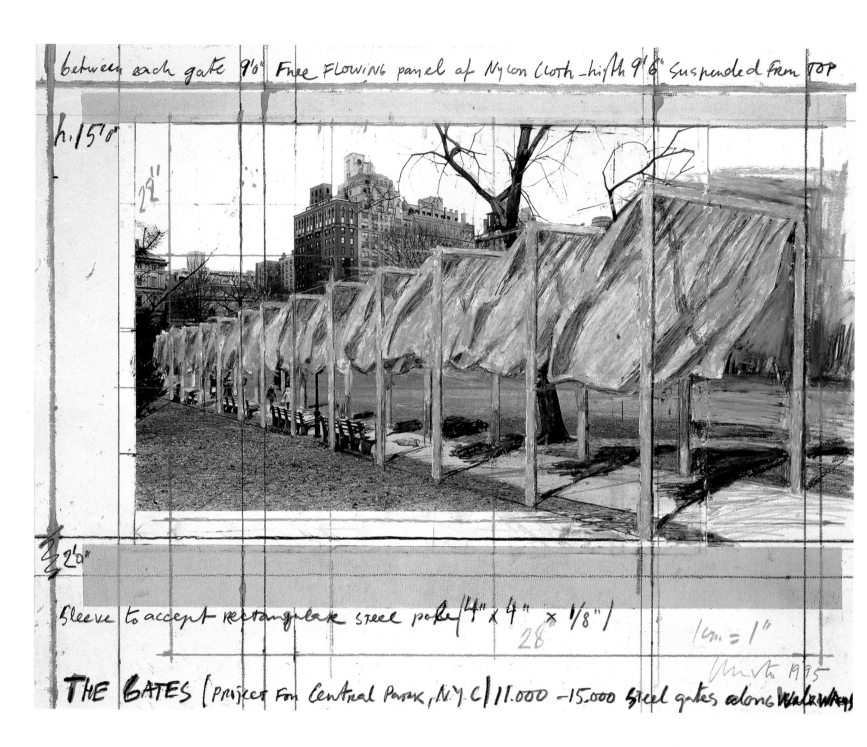

between each gate 9'0" Free FLOWING panel of Nylon Cloth - high 9'6" suspended from TOP

h. 15'0"

28"

2'0"

sleeve to accept rectangular steel pole (4" x 4" x 1/8")

28

1cm = 1"

Christo 1995

THE GATES (Project For Central Park, N.Y.C | 11.000 - 15.000 steel gates along WalkWays

The Gates, Project for Central Park, New York City.
Collage 1995.
28 x 35,5 cm (11 x 14").
Pencil, enamel paint, photograph by Wolfgang Volz,
wax crayon, charcoal and tape.

The Gates, Project for
Central Park, New York City.
Collage 2002.
35,5 x 28 cm (14 x 11").
Pencil, enamel paint, photo-
graph by Wolfgang Volz, wax
crayon, map and tape on
brown board.

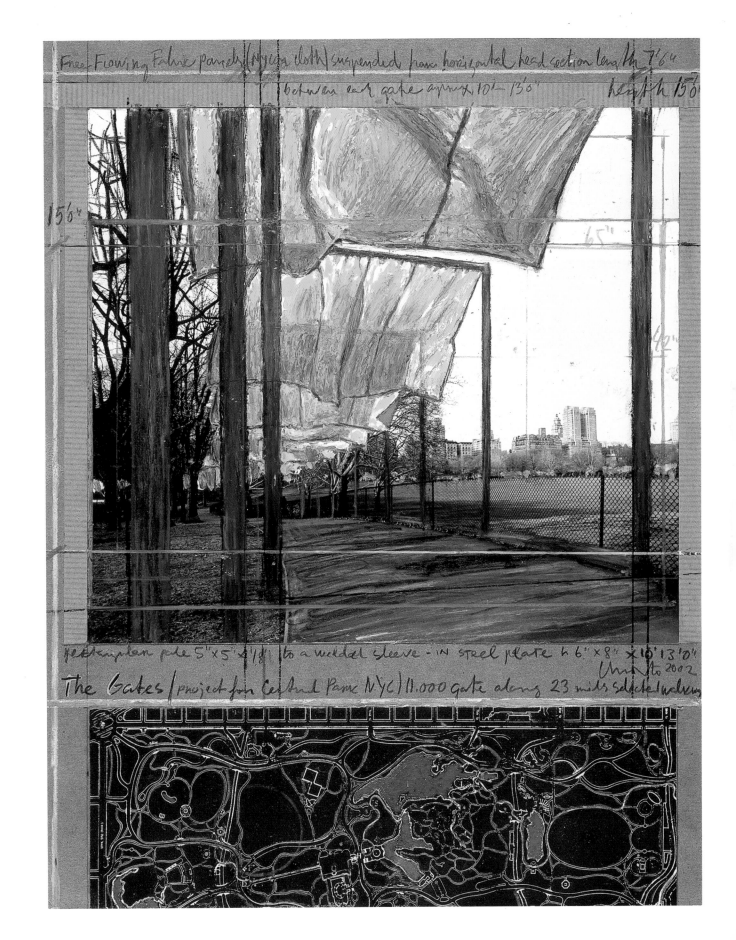

The Gates (project for Central Park NYC) 11,000 Gate along 23 miles selected walkways

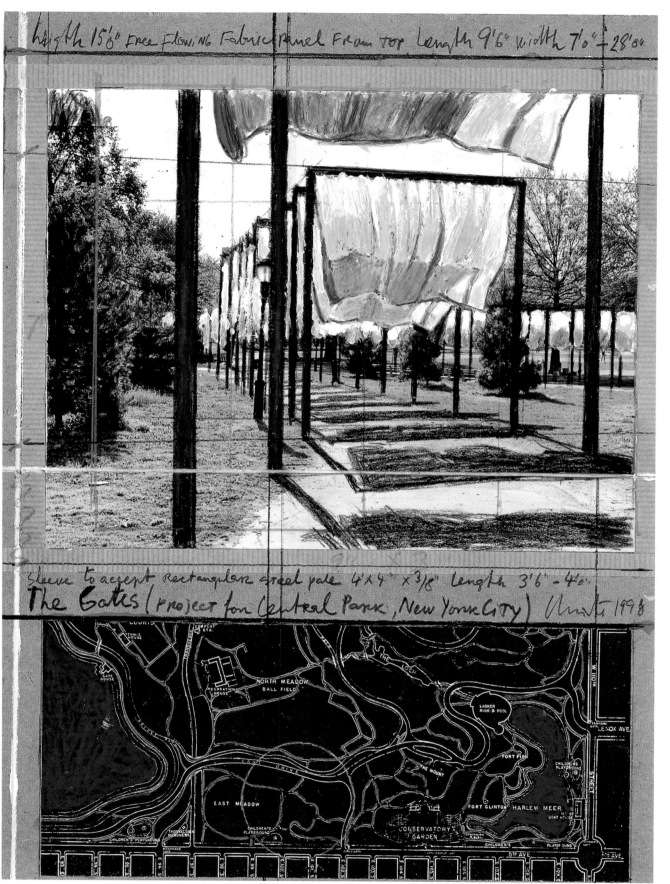

length 15'8" Free Flowing Fabric Panel From Top Length 9'6" Width 7'0" - 28'00

Sleeve to accept rectangular steel pole 4"x4" x 3/8" Length 3'6" - 4'0".

The Gates (Project for Central Park, New York City) Christo 1998

The Gates, Project for
Central Park, New York City.
Collage 1998.
35,5 x 28 cm (16 x 11").
Pencil, enamel paint, photo-
graph by Wolfgang Volz,
charcoal, wax crayon, map
and tape on brown cardboard.

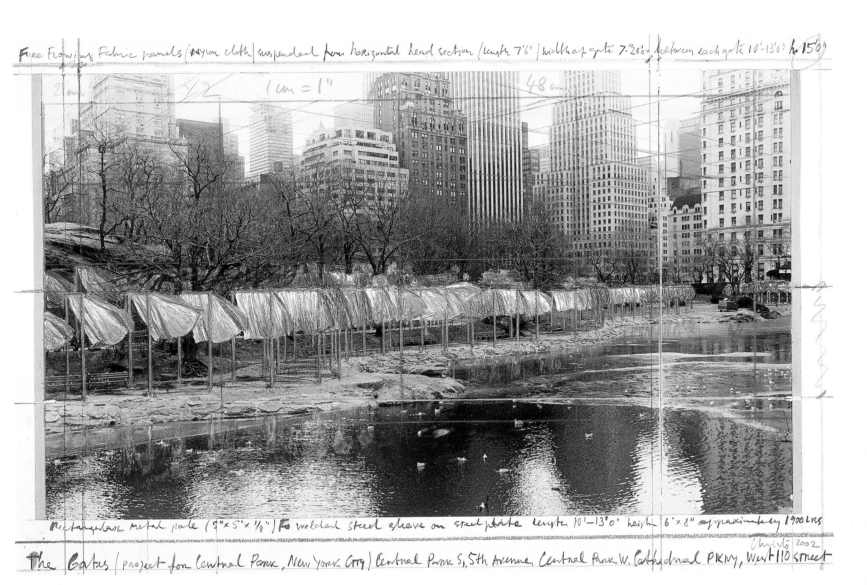

Free Flowing Fabric panels (nylon cloth) suspended from horizontal head section (length 7'6" / width of gate 7'-20'6" / between each gate 10'-130'0" / h 150'0"

2 cm 5/2 1 cm = 1" 48 cm

Rectangular metal pole (5"x5"x1/8") to welded steel sleeve on steel plate length 10'-13'0" height 6"x8" approximately 1900 LBS

Christo 2002
The Gates (project for Central Park, New York City) Central Park S, 5th Avenue, Central Park W. Cathedral PKWY, West 110 street

The Gates, Project for
Central Park, New York City.
Collage 2002.
35,5 x 55,9 cm (14 x 22").
Pencil, enamel paint, photo-
graph by Wolfgang Volz,
wax crayon and tape.

The Gates, Project for Central Park, New York City.
Collage 2002.
In two parts:
77,5 x 30,5 cm and 77,5 x 66,7 cm
(30.1/2" x 12" and 30.1/2" x 26.1/4").
Pencil, fabric, wax crayon, charcoal, pastel and
aerial photograph.

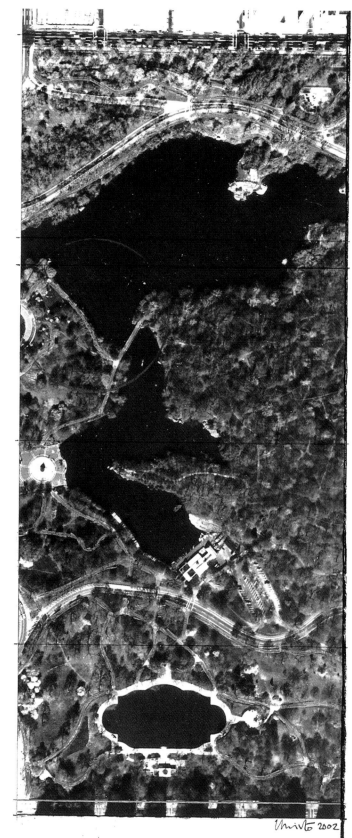

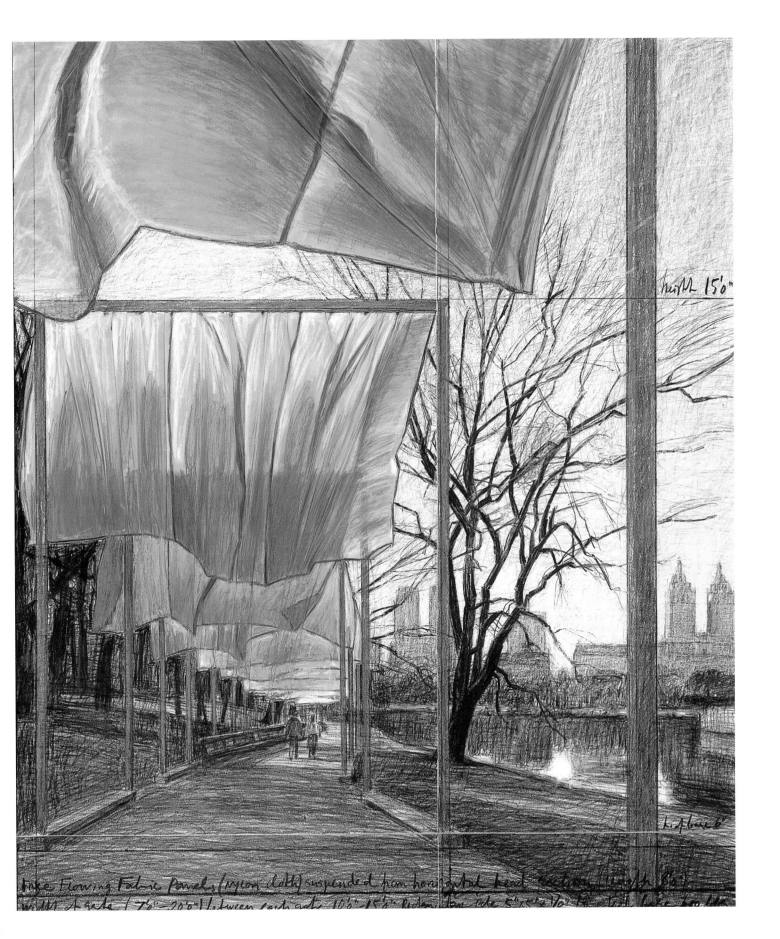

height 15'0"

Free Flowing Fabric Panels (nylon cloth) suspended from horizontal head sections. Width 9'0"
width of gate 12'0"-20'0". between each gate 10'0"-15'0" Perpendicular to the Earth's Vapor Roof Height 10'0"

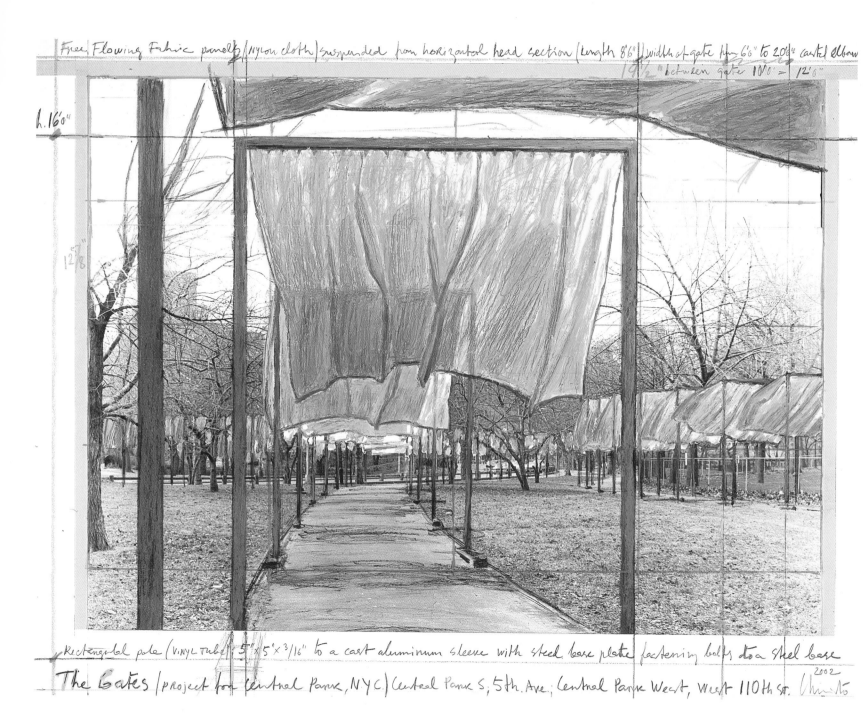

Free Flowing Fabric panels (Nylon cloth) suspended from horizontal head section (length 8'6") width of gate from 6'6" to 20'8" canted elbow

9½" between gate 10'0" = 12'0"

h.16'0"

12'8"

Rectangular pole (Vinyl tube) 5" x 5" x 3/16" to a cast aluminum sleeve with steel base plate fastening bolts to a steel base

The Gates / Project for Central Park, NYC) Central Park S, 5th. Ave; Central Park West, West 110th St. Christo 2002

The Gates, Project for Central Park,
New York City.
Collage 2002.
43,2 x 55,9 cm (17 x 22").
Pencil, enamel paint, photograph by
Wolfgang Volz, wax crayon and tape.

CHRISTO and JEANNE-CLAUDE

BIOGRAPHY

1935 Christo: American, born Christo Javacheff, June 13, Gabrovo, of a Bulgarian industrialist family.
Jeanne-Claude : American, born Jeanne-Claude de Guillebon, June 13, Casablanca, of a French military family, educated in France and Switzerland.
1952 Jeanne-Claude : Baccalaureat in Latin and Philosophy, University of Tunis.
1953-56 Christo : Studies at Fine Arts Academy, Sofia. 1956, arrival in Prague.
1957 He studies one semester at the Vienna Fine Arts Academy.
1958 Christo arrives in Paris where he meets Jeanne-Claude. "Packages" and "Wrapped Objects"
1960 Birth of their son, Cyril, May 11.
1961 "Project for the Wrapping of a Public Building"
"Stacked Oil Barrels" and "Dockside Packages" at Cologne Harbor, their first collaboration.
1962 "Iron Curtain-Wall of Oil Barrels" blocking the Rue Visconti, Paris.
"Stacked Oil Barrels", Gentilly, near Paris. "Wrapping a Girl", London.
1963 "Showcases".
1964 Establishment of permanent residence in New York City. "Store Fronts" and "Show Windows".
1966 "Air Package" and "Wrapped Tree", Stedelijk van Abbemuseum, Eindhoven, Holland.
"42,390 Cubic Feet Package" at the Walker Art Center and the Minneapolis School of Art.
1968 "Wrapped Fountain" and "Wrapped Medieval Tower", Spoleto.
Wrapping of a public building "Wrapped Kunsthalle Berne".
"5,600 Cubicmeter Package, Documenta 4, Kassel" an Air Package 280 feet high, foundations arranged in a 900 foot diameter circle. "Corridor Store Front", total area : 1,500 sq.ft.
"1,240 Oil Barrels Mastaba", and "Two Tons of Stacked Hay", I.C.A., Philadelphia.
1969 "Wrapped Museum of Contemporary Art, Chicago", 10.000 square feet of tarpaulin.
"Wrapped Floor and Stairway", 2,800 square feet of drop cloths, Museum of Contemporary Art, Chicago.
"Wrapped Coast, Little Bay, One Million Square Feet, Sydney, Australia", 90.000 square meters (One million square feet) Erosion Control fabric and 36 miles of ropes.
Project for stacked Oil Barrels "Houston Mastaba, Texas", 1,249,000 barrels.
Project for "Closed Highway".
1970 Wrapped Monuments, Milano : "Monument to Vittorio Emanuele, Piazza Duomo ; Monument to Leonardo da Vinci, Piazza Scala".
1971 "Wrapped Floors, Covered Windows and Wrapped Walk Ways", Haus Lange, Krefeld, Germany.
1972 "Valley Curtain, Grand Hogback, Rifle, Colorado, 1970-72", width : 1,250,- 1,368 feet, height : 185-365 feet, 142,000 square feet of nylon polyamide, 110,000 lbs. of steel cables, 800 tons of concrete.
1974 "The Wall, Wrapped Roman Wall, Via V. Veneto and Villa Borghese, Rome".
"Ocean Front, Newport, Rhode Island" 150,000 square feet of floating polypropylene fabric over the ocean.
1976 "Running Fence, Sonoma and Marin Counties, California, 1972-76", 18 feet high, 24-1/2 miles long, 240,000 square yards of woven nylon fabric, 90 miles of steel cables, 2,050 steel poles (each : 3-1/2 inch diameter, 21 feet long).
1977 "The Mastaba of Abu Dhabi, Project for the United Arab Emirates" *in progress*.
1978 "Wrapped Walk Ways, Loose Park, Kansas City, Missouri, 1977-78" 15.000 square yards of woven nylon fabric over 2.8 miles of walkways.
1979 "The Gates, Project for Central Park, New York City" *in progress*.
1983 "Surrounded Islands, Biscayne Bay, Greater Miami, Florida, 1980-83" 6.5 million sq. ft. pink woven polypropylene fabric.
1984 "Wrapped Floors and Stairways and Covered Windows" of Architecture Museum, Basel, Switzerland.
1985 "The Pont Neuf Wrapped, Paris, 1975-85", 454,178 sq. ft. of woven polyamide fabric, 42,900 ft. of rope.
1991 "The Umbrellas, Japan-U.S.A., 1984-91", 1,340 blue umbrellas in Ibaraki, Japan ; 1,760 yellow umbrellas in California, USA. Each : height : 19 ft. 8 in., diameter : 28 ft. 6 in.
1992 "Over The River, Project for The Arkansas River, Colorado" *in progress*.
1995 "Wrapped Floors and Stairways and Covered Windows" Museum Würth, Künzelsau, Germany.
"Wrapped Reichstag, Berlin, 1971-95", 100,000 sq. meters (1,076,000 sq. ft.) of polypropylene fabric, 15,600 meters (51,181 feet) of rope and 200 metric tons of steel.

1998 "Wrapped Trees, Fondation Beyeler and Berower Park, Riehen-Basel, Switzerland 1997-98". 178 trees, 53,283 sq. meters (592,034 sq.ft) of woven polyester fabric, 23 km (14.3 miles) of rope.
1999 "The Wall, 13,000 Oil Barrels, Gasometer, Oberhausen, Germany", an indoor installation.

BIBLIOGRAPHY

BOOKS

1965 *Christo*. Texts by David Bourdon, Otto Hahn and Pierre Restany. Designed by Christo. Edizioni Apollinaire, Milano, Italy.
1968 *Christo : 5,600 Cubic Meter Package.* Photographs by Klaus Baum. Designed by Christo. Verlag Wort und Bild, Baierbrunn, Germany.
1969 *Christo.* Text by Lawrence Alloway. Designed by Christo. Harry N. Abrams Publications, New York, USA. Verlag Gerd Hatje, Stuttgart, Germany. Thames and Hudson, London, England.
1969 *Christo : Wrapped Coast, One Million Square Feet.* Photographs by Shunk-Kender. Designed by Christo. Contemporary Art Lithographers, Minneapolis, USA.
1970 *Christo.* Text by David Bourdon. Designed by Christo. Harry N. Abrams Publications, New York, USA.
1971 *Christo : Projeckt Monschau.* By Willi Bongard. Verlag Art Actuell, Köln, Germany.
1973 *Christo : Valley Curtain.* Photographs by Harry Shunk. Designed by Christo. Verlag Gert Hatje, Stuttgart, Germany ; Harry N. Abrams Publications, New York, USA. Pierre Horay, Paris, France. Gianpaolo Prearo, Milano, Italy.
1975 *Christo : Ocean Front.* Text by Sally Yard and Sam Hunter. Photographs by Gianfranco Gorgoni. Edited by Christo. Princeton University Press, New Jersey, USA.
1975 Environmental Impact Report : Running Fence. Prepared by Paul E. Zigman and Richard Cole, Environmental Science Associates Inc., Foster City, California, USA.
1977 *Christo : The Running Fence.* Text by Werner Spies. Photographs and editing by Wolfgang Volz. Harry N. Abrams, Inc., New York, USA (in English). Edition du Chêne, Paris, France (in French). Editions Gerd Hatje, Stuttgart, Germany (in Germany).
1978 *Christo : Running Fence.* Chronicle by Calvin Tomkins. Narrative text by David Bourdon. Photographs by Gianfranco Gorgoni. Designed by Christo. Harry N. Abrams, Inc., New York, USA.
1978 *Christo : Wrapped Walk Ways.* Essay by Ellen Goheen. Photographs by Wolfgang Volz. Designed by Christo. Harry N. Abrams, Inc., New York, USA.
1980 *Catalogue Raisonné of original works.* Being prepared by Daniel Varenne. With the collaboration of Ariane Coppier, Marie-Claude Blancpain and Raphaëlle de Pourtales, in progress.
1982 *Christo-Complete Editions 1964-82.* Catalogue Raisonné. Introduction by Per Hovdenakk. Verlag Schellmann and Kluser, München, Germany. New York University Press, New York, USA.
1984 *Christo : Works 1958-83.* Text by Yusuke Nakahara. Publication Sogetsu Shuppan, Inc., Tokyo, Japan.
1984 *Christo : Surrounded Islands, Biscayne Bay, Greater Miami, Florida, 1980-83.* Text by Werner Spies, photographs and editing by Wolfgang Volz. Dumont Buchverlag, Köln, Germany. Harry N. Abrams, Inc., New York, USA, 1985. Fondation Maeght, Saint-Paul de Vence, France, 1985. Ediciones Poligrafa, Barcelona, Spain, 1986.
1984 *Christo - Der Reichstag.* Compiled by Michael Cullen and Wolfgang Volz. Photographs by Wolfgang Volz. Suhrkamp Verlag, Frankfurt, Germany.
1985 *Christo.* Text by Dominique Laporte. Publication : Art Press / Flammarion, Paris, France. English edition by Pantheon Books, New York, USA, 1986.
1986 *Christo : Surrounded Islands, Biscayne Bay, Greater Miami, Florida, 1980-83.* Photographs by Wolfgang Volz. Introduction and Picture Commentary by David Bourdon. Essay by Jonathan Fineberg. Report by Janet Mulholland. Designed by Christo. Harry N. Abrams, Inc., New York, USA.
1987 *Le Pont-Neuf de Christo, Ouvrage d'Art, Oeuvre d'Art, ou Comment Se Faire une Opinion.* By Nathalie Heinich. Photographs by Wolfgang Volz. A.D.R.E.S.S.E. Publication.
1987 *Helt Fel I Paris.* By Pelle Hunger and Joakim Stromholm. Photographs by J. Stromholm. Butler and Tanner Ltd. The Selwood Printing Works, Fromme, England.
1988 *Christo : Prints and Objects, 1963-1987.* Catalogue Raisonné edited by Jörg Schellmann and Josephine Benecke. Introduction by Werner Spies. Editions Schellmann, München, Germany. Abbeville Press, New York, USA.
1990 *Christo : The Pont Neuf Wrapped, Paris, 1975-85.* Photographs by Wolfgang Volz. Texts by David Bourdon and Bernard de Montgolfier. Designed by

Christo. Harry N. Abrams Inc., New York, USA. Adam Biro, Paris, France. Dumont Buchverlag, Köln, Germany.

1990 *Christo.* By Yusuke Nakahara. Shinchosha Co., Ltd., Tokyo, Japan.

1990 *Christo.* By Marina Vaizey. Poligrafa, Barcelona, Spain. Rizzoli, New York, USA. Albin Michel, Paris, France. Meulenhoff/Landshoff, Amsterdam, Holland. Verlag Aurel Bongers, Recklinghausen, Germany. Bijutsu Shupan-Sha, Tokyo, Japan.

1991 *Christo : The Accordion-Fold Book for The Umbrellas, Joint Project for Japan and U.S.A.* Photographs by Wolfgang Volz. Foreword and interview by Masahiko Yanagi. Designed by Christo. Chronicle Books, San Francisco, USA.

1993 *Christo : The Reichstag and Urban Projects.* Edited by Jacob Baal-Teshuva. Photographs by Wolfgang Volz. Contributions by Tilmann Buddensieg, Michael S. Cullen, Rita Süssmuth and Masahiko Yanagi. In German for the exhibitions at the Kunsthaus Wien, Austria - the Villa Stück, Munich - and the Ludwig Museum, Aachen. Prestel Publications, München, Germany. In English for Prestel Publications, USA.

1994 *Christo and Jeanne-Claude : Der Reichstag und Urbane Projekte.* Edited by Jacob Baal-Teshuva. Contributions by Tilmann Buddensieg and Wieland Schmied. Interview by Masahiko Yanagi. Chronology by Michael S. Cullen. Photographs by Wolfgang Volz. Prestel Verlag, München, Germany.

1995 *Christo & Jeanne-Claude.* By Jacob Baal-Teshuva. Photographs by Wolfgang Volz. Designed by Christo. Edited by Simone Philippi and Charles Brace. Benedikt Taschen Verlag GmbH, Köln, Germany.

1995 *Christo, Jeanne-Claude, Der Reichstag dem Deutschen Volke.* By Michael S. Cullen and Wolfgang Volz. Photographs by Wolfgang Volz. Bastei-Lübbe, Gustav Lübbe Verlag GmbH, Bergisch-Gladbach, Germany.

1995 *Christo and Jeanne-Claude, Prints and Objects 1963-95.* Catalogue Raisonné. Edited by Jörg Schellmann and Joséphine Benecke. Editions Schellmann, München-New York. Schirmer Mosel Verlag München, Germany.

1995 *Christo & Jeanne-Claude Postcardbook.* Benedikt Taschen Verlag GmbH, Köln, Germany.

1995 *Christo & Jeanne-Claude, Poster Book.* Photographs by Wolfgang Volz. Text by Thomas Berg, Bonn, Benedikt Taschen Verlag GmbH, Köln, Germany.

1995 *Christo and Jeanne-Claude : Wrapped Reichstag, Berlin, 1971-95. The Project Book.* Photographs by Wolfgang Volz. Benedikt Taschen Verlag, GmbH, Köln, Germany.

1996 *Christo and Jeanne-Claude, Wrapped/Verhüllter Reichstag, Berlin 1971-1995.* Photographs by Wolfgang Volz. Picture Notes by David Bourdon. Edited by Simone Philippi. Designed by Christo. 700 pages. Benedikt Taschen Verlag GmbH, Köln, Germany.

1996 *Christo and Jeanne-Claude Projects selected from the Lilja Collection.* Second Edition. Photographs by Wolfgang Volz. Preface by Torsten Lilja. Text by Per Hovdenakk. Azimuth Editions Limited, London, England.

1998 *Christo and Jeanne-Claude. The Umbrellas, Japan-USA, 1984-91.* Photographs by Wolfgang Volz, Picture notes by Jeanne-Claude and Masa Yanagi. Designed by Christo. Edited by Simone Philippi. 1.400 pages, two volumes in one box. Benedikt Taschen Verlag GmbH, Köln, Germany.

1998 *Christo and Jeanne-Claude, Wrapped Trees, 1997-98.* Photographs and Picture Notes by Wolfgang and Sylvia Volz. Introduction by Ernst Beyeler. Edited by Simone Philippi. Benedikt Taschen Verlag GmbH, Köln, Germany, 136 pages.

1998 *Christo and Jeanne-Claude, Erreurs les Plus Fréquentes.* Edited by Jeanne-Claude. In French. Editions Jannink, Paris.

2000 *Most Common Errors / Erreurs Les Plus Fréquentes.* Edited by Jeanne-Claude. English and French. Editions Jannink, Paris.

2000 *XTO + J-C.* Christo und Jeanne-Claude, Eine Biografie von Burt Chernow, Epilog von Wolfgang Volz. 496 pages, 55 illustrations plus 28 in color. (in German). Verlag Kiepenheuer & Witsch, Köln, Germany.

2001 *XTO + J-C.* Christo e Jeanne-Claude, Biografia de Burt Chernow, Epilogo de Wolfgang Volz (in Italian). 366 pages, 99 illustrations plus 28 in color. Publacation Skira Italy. Fondazione Ambrosetti Arte Contemporanea, Skira, Italy.

2002 *XTO + J-C.* Christo and Jeanne-Claude, a Biography by Burt Chernow, Epilogue by Wolfgang Volz (in English). Saint Martin's Press, New York.

CATALOGUES FOR PERSONAL EXHIBITIONS (PARTIAL LISTING)

1961 Galerie Haro Lauhus, Köln, Germany. Text by Pierre Restany. Poem by Stephan Wewerka.

1962 Rue Visconti, Paris. *Le Docker et le Décor.* Text by Pierre Restany.

1966 Stedelijk van AbbeMuseum, Eindhoven, The Netherlands. Text by Lawrence Alloway.

1968 Museum of Modern Art, New York, USA, *Christo Wraps the Museum.* Text by William Rubin.

1968 I.C.A. University of Pennsylvania, Philadelphia, USA. Text by Stephen Prokopoff.

1969 National Gallery of Victoria, Melbourne, Australia. *Woolworks.* Text by Jan van der Marck.

1971 Haus Lange Museum, Krefeld, Germany. *Wrapped Floors, Covered Windows* and *Wrapped Walk Ways.* Text by Paul Wember.

1971 Museum of Fine Arts, Houston, Texas, USA. *Valley Curtain, Project for Rifle, Colorado, in progress. Documentation.* Text by Jan van der Marck.

1973 Kunsthalle, Düsseldorf, Germany, *Valley Curtain, Documentation Exhibition.* Text by Joh, Matheson. Photographs by Harry Shunk.

1974 Musée de Peinture et de Sculpture, Grenoble, France. *Valley Curtain, 1970-72, Documentation Exhibition.* Text by Maurice Besset.

1975 Galerie Ciento, Barcelona, Spain. Text by Alexandre Cirici.

1975 Museo de Bellas Artes, Caracas. *Exposicion Documental Sobre El Valley Curtain.* Photographs by Harry Shunk. Impression Editorial Arte, Caracas, Venezuela.

1977 Minami Gallery, Tokyo, Japan. Text by Yusuke Nakahara.

1977 Landische Museum, Bonn, Germany. *Wrapped Reichstag. Project for Berlin.* Texts by Wieland Schmied and Tilmann Buddensieg.

1977 Annely Juda Fine Art, London, England. *Wrapped Reichstag, Project for Berlin.* Photographs by Wolfgang Volz. Texts by Wieland Schmied and Tilmann Buddensieg.

1978 Galerie Art in Progress, München, Germany. *Galerien Maximilianstrasse.* Text by Albrecht Haenlein.

1978 Rijksmuseum Kröller-Müller, Otterlo, The Netherlands. *The Mastaba.* Introduction by R.W.D. Oenaar and text by Ellen Joosten.

1979 Wiener Secession. Wien, Austria. *Running Fence, Documentation Exhibition.* Photographs by Wolfgang Volz. Text by Werner Spies. Introduction by Herman J. Painitz.

1979 I.C.A., Boston, USA - Laguna Gloria Art Museum, Austin, Texas - Corcoran Gallery of Art, Washington D.C. *Urban Projects.* Introduction by Stephen Prokopoff. Text by Pamela Allara and Stephen Prokopoff.

1981 Museum Ludwig, Köln, Germany. Staedel Museum, Frankfurt, Germany. *Urban Projects.* Introduction by Karl Ruhrberg and Klaus Gallwitz. Text by Evelyn Weiss and Gerhard Kolberg.

1981 Juda-Rowan Gallery, London, England. *Surrounded Islands, Project for Florida.* Photographs by Wolfgang Volz. Text by Anitra Thorhaug.

1981 La Jolla Museum of Contemporary Art, La Jolla, California, USA. *Collection on Loan from the Rothschild Bank AG,* Zürich. Introduction by Robert McDonald. Text by Jan van der Marck.

1982 Hara Museum of Contemporary Art, Tokyo, Japan. *Wrapped Walk Ways.* Photographs by Wolfgang Volz. Texts by Toshio Hara, Ellen R. Goheen and Toshio Minemura. Fondation Arc-en-Ciel, Tokyo.

1982 U.A.E. University, Al-Ain, United Arab Emirates. *Environmental Art Works.* Photographs by Harry Shunk and Wolfgang Volz. Foreword by Ezzidin Ibrahim.

1984 Satani Gallery, Tokyo, Japan. *The Pont Neuf Wrapped, Project for Paris.* Photographs by Wolfgang Volz. Text by Yusuke Nakahara. Interview by Masahiko Yanagi.

1984 Juda-Rowan Gallery, London, England. *Objects, Collages and Drawings. 1958-84.*

1984 Architekturmuseum, Basel, Switzerland. *Wrapped Floors, im Architekturmuseum in Basel.* Text by Ulrike and Werner Jehle-Schulte. Photographs by Wolfgang Volz.

1986 Satani Gallery, Tokyo, Japan. *Wrapped Reichstag. Project for Berlin.* Photographs by Wolfgang Volz. Interview by Masahiko Yanagi.

1986 Galeria Joan Prats, Barcelona, Spain. *Dibuixos i Collages.*

1987 Museum of Contemporary Art, Gent, Belgium. *Surrounded Islands, Documentation Exhibition.* Photographs by Wolfgang Volz. Text by Werner Spies.

1987 Seibu Museum of Art, Tokyo, Japan. *A Collection on Loan from the Rothschild Bank, Zürich.* Texts by Torsten Lilja, Yusuke Nakahara, Tokuhiro Nakajima and Akira Moriguchi. Interview by Masahiko Yanagi. Photographs by Wolfgang Volz.

1987 Centre d'Art Nicolas de Staël, Braine-L'Alleud, Belgium. *Dessins, Collages, Photographs.* Text by A.M. Hammacher. Interviews by Marcel Daloze and Dominique Verhaegen. Photographs by Wolfgang Volz.

1987 Edition Mönchehaus-Museum Verein zur Förderung Moderne Kunst, Goslar, Germany. *Laudation zur Verleihung des Kaiserrings, Goslar, September 26, 1987, Germany.* Text by Werner Spies. Photographs by Wolfgang Volz.

1988 Satani Gallery, Tokyo, Japan. *The Umbrellas, Joint Project for Japan and USA.* Photographs by Wolfgang Volz. Introduction by Ben Yama. Text by Masahiko Yanagi.

1988 Annely Juda Fine Art, London, England. *The Umbrellas, Joint Project for Japan and USA.* Photographs by Wolfgang Volz. Interview and text by Masahiko Yanagi.

1988 Taipei Fine Arts Museum, Taipei, Taiwan. *Collection on Loan From the Rothschild Bank AG. Zürich.* Preface by Kuang-Nan Huang. Texts by Werner Spies and Joseph Wang. Photographs by Wolfgang Volz.

1989 Guy Pieters Gallery, Knokke-Zoute, Belgium. *The Umbrellas, Joint Project for Japan and USA*. Photographs by Wolfgang Volz. Text by Masahiko Yanagi. Picture commentary by Susan Astwood.

1989 Musée d'Art Moderne et d'Art Contemporain, Nice, France. *Selection from the Lilja Collection*. Texts by Torsten Lilja, Claude Fournet, Pierre Restany, Werner Spies and Masahiko Yanagi. Photographs by Wolfgang Volz.

1989 Galerie Catherine Issert, St. Paul de Vence, France. *Works : 1965-1988*. Text by Raphael Sorin.

1990 The Henie-Onstad Art Centre, Høvikodden, Norway. *Works 1958-89, from the Lilja Collection*. Introduction by Torsten Lilja. Text by Per Hovdenakk. Interview by Jan Åman. Photographs by Wolfgang Volz.

1990 Hiroshima City Museum of Contemporary Art - Japan. Hara Museum, ARC, Gunma, Japan - Fukuoka Art Museum, Japan. *Surrounded Islands, Documentation Exhibition*. Photographs by Wolfgang Volz. Text by Jonathan Fineberg.

1990 The Art Gallery of New South Wales, Sydney, Australia. *Works from 1958-1990*. Foreword by John Kaldor. Texts by Albert Elsen, Toni Bond, Daniel Thomas and Nicholas Baume. Photographs by Wolfgang Volz.

1990 Bogerd Fine Art, Amsterdam, Holland. *Drawings-Multiples*.

1990 Gallery Seomi, Seoul, Korea. *Prints and Lithographs*.

1990 Satani Gallery, Tokyo, Japan. *The Umbrellas, Joint Project for Japan and USA*. Photographs by Wolfgang Volz. Text by Masahiko Yanagi.

1991 Annely Juda Fine Art, London, England. *Projects Not Realized and Works in Progress*. Foreword by Annely Juda and David Juda.

1991 Galeria Joan Prats, Barcelona, Spain. *Obra 1958-1991*. Text by Marina Vaizey.

1991 Art Tower Mito, Ibaraki, Japan. *Valley Curtain, Documentation Exhibition. And The Umbrellas, Joint Project for Japan and USA, Work in Progress*. Photographs by Harry Shunk and Wolfgang Volz. Text by Jan van der Marck. Interview by Masahiko Yanagi.

1991 Satani Gallery, Tokyo, Japan. *Early Works 1958-64*. Text by Masahiko Yanagi and Harriet Irgang.

1992 Gallery Seomi and Gallery Hyundai, Seoul, Korea. *Works from 80's and 90's*. Exhibitions curated by Carl Flach. Photographs by Wolfgang Volz.

1992 Marugame Genichiro Inokuma Museum of Contemporary Art, Japan. *Valley Curtain, Documentation Exhibition. The Umbrellas, Japan-USA*. Photographs by Harry Shunk and Wolfgang Volz. Text by Jan van der Marck. Interview by Masahiko Yanagi.

1993 Art Front Gallery, Hillside Terrace, Tokyo, Japan. *Works from the 80's and 90's*. Photographs by Wolfgang Volz. Curated by Carl Flach. Text compiled by Masahiko Yanagi.

1993 *The Reichstag and Urban Projects*. Edited by Jacob Baal-Teshuva. Photographs by Wolfgang Volz. Contributions by Tilmann Buddensieg and Wieland Schmied. Interview by Masahiko Yanagi. Chronology by Michael S. Cullen. Prestel-Verlag, München, Germany.

1994 Kunstmuseum, Bonn, Germany. *Christo, The Pont Neuf Wrapped, Paris, 1975-85*. Photographs by Wolfgang Volz. Excerpts from Jeanne-Claude's Agenda. Texts by Volker Adolphs, Bernard de Montgolfier, Dieter Ronte and Constance Sherak.

1995 *Christo and Jeanne-Claude Projects selected from the Lilja Collection*. First Edition. Photographs by Wolfgang Volz. Preface by Torsten Lilja. Text by Per Hovdenakk, Azimuth Editions Limited, London, England.

1995 Museum Würth, Künzelsau, Germany. *The Works in the Collection Würth*. Texts by Lothar Romain and C. Sylvia Weber. Photographs by Wolfgang Volz. Thorbecke Verlag, Sigmaringen 1995, Germany.

1995 Museum Würth, Künzelsau, Germany. *Wrapped Floors and Stairways and Covered Windows*. Photographs by Wolfgang Volz. Edited by C. Sylvia Weber. Texts by Wulf Herzogenrath, Hans Georg Frank, Sibylle Peine, Andreas Sommer, Wolfgang Reiner and Christian Marquart. Thorbecke Verlag, Sigmaringen 1995, Germany.

1995 Annely Juda Fine Art, London, England. *Christo and Jeanne-Claude. Three Works in Progress*. Foreword by Annely Juda and David Juda. Photographs by Wolfgang Volz.

1995 Art Front Gallery, Tokyo, Japan. *Wrapped Reichstag, Berlin, and Works in Progress*. Photographs by Wolfgang Volz, Sylvia Volz, André Grossmann, Michael Cullen and Yoshitaka Uchida.

1997 Yorkshire Sculpture Park, U.K. *Christo & Jeanne-Claude. Sculpture and Projects 1961-96*. Preface by Peter Murray. Designed and produced by Claire Glossop.

1997 The Museum of Sketches, Lund, Sweden. *Christo and Jeanne-Claude Projects, works from the Lilja Collection*. Introduction by Jan Torsten Ahlstrand. Photographs by Wolfgang Volz.

1998 Galerie Guy Pieters, Belgium. *Christo and Jeanne-Claude, The Gates, Project for Central Park, New York ; and Over The River, Project for the Arkansas River, Colorado*. Photographs by Wolfgang Volz. Designed by Christo. Picture notes by Jeanne-Claude and Jonathan Henery.

1998 Galerie Beyeler, Basel, Switzerland. *Christo and Jeanne-Claude*. Exerpts from a text by David Bourdon. Text by Werner Spies.

1999 IBA, Gasometer, Oberhausen, Germany. *Christo and Jeanne-Claude : The Umbrellas, Japan-USA, A documentation Exhibition. Wrapped Reichstag. Berlin, 1971-95, A Documentation Exhibition. The Wall - 13,000 Oil Barrels*. Photographs by Wolfgang Volz. Preface by Prof. Karl. Ganser. Texts by Marion Taube, David Bourdon and Wolfgang Volz. Edited by Simone Philippi. Benedikt Taschen Verlag GmbH, Köln, Germany.

2000 Annely Juda Fine Art, London, England. *Christo and Jeanne-Claude. Black and White*.

2001 "Christo e Jeanne-Claude, Progetti Recenti, Progetti Futuri". Projects and Realisations for Wrapped Trees, 1966-98; Projects and Realisations with Oil Barrels 1958-82, and 13,000 Oil Barrels, Oberhausen 1999 : Two Works in Progress : Over the River and The Gates". Palazzo Bonoris, Brescia, Italy. Organized by Fondazione Ambrosetti Arte Contemporanea. March 11 to May 21. Catalogue : Texts by Loredana Parmesani, Ettore Camuffo, Marion Taube, Christo and Jeanne-Claude. Photographs by : Wolfgang Volz, Eeva-Inkeri, Jean-Dominique Lajoux, Harry Shunk, Ferdinand Boesch, André Grossmann.

"Christo and Jeanne-Claude : The Art of Gentle Disturbance". Macy Gallery, Teachers College, Columbia University, New York, USA. (Brochure : photographs by Wolfgang Volz, Jean-Dominique Lajoux and Harry Shunk.

"Christo and Jeanne-Claude. Two Works in Progress : Over the River, Project for the Arkansas River, Colorado, and The Gates, Project for Central Park, New York". Sta.. University Art Gallery, Kennesaw, Georgia, USA. (Brochure: photographs by Wolfgang Volz).

"Christo and Jeanne-Claude. The Gates, Project for Central Park New York City and Over The River, Project for The Arkansas River, Colorado Two Works in Progress." Guy Pieters Gallery, Saint Paul de Vence, France. June 16 to July 30. Catalogue : (2 catalogues in a box, edition 2001 "Over the River" : picture commentary by Jeanne-Claude and Jonathan Henery, photographs by Wolfgang Volz, Sylvia Volz and Simon Chaput. "The Gates" : picture commentary by Jeanne-Claude and Jonathan Henery, photographs by André Grossmann and Wolfgang Volz. (In English and in German)

Catalogue : "Christo and Jeanne-Claude : Early Works 1958-69" : Texts by Lawrence Allow, David Bourdon, Jan van der Marck, photographs by Ferdinand Boesch, Thomas Cugini, Andre Grossmann Eeva-Inkeri, Jean-Dominique Lajoux, Harry Shunk, Wolfgang Volz, Stefan Wewerka and many others. Catalogue "Wrapped Reichstag" pictures commentary by David Bourdon, Michael S. Cullen, Christo and Jeanne-Claude, photographs by Wolfgang Volz. Taschen Verlag Publications.

2002 "Christo and Jeanne-Claude in the Vogel Collection." National Gallery of Art, Washington, DC, USA. February 3 to June 23. (Catalogue : Introduction by Earl A. Powell, III; Text and interview by Molly Donovan, photographs by Wolfgang Volz.

2002 Christo and Jeanne-Claude - The Weston Collection, Toronto, Canada. The Gallery at Windsor and Vero Beach Museum of Art, Florida. 8 December 2002 - March 21, 2003. Foreword by W. Galen Weston, Essay by Molly Donovan. Photographs by Wolfgang Volz, and additional photographs by Simon Chaput, Jean Desjardins, André Grossmann, Eeva-Inkeri, Thomas Moore, Harry Shunk. Published by George Weston Limited.

2002 Christo and Jeanne-Claude - The Gates, Project for Central Park New York City, A Work in Progress, Guy Pieters Gallery, Knokke (Belgium) at the Paris FIAC, October 23rd to October 28th. Catalogue: Photographs by Wolfgang Volz, Picture Commentary by Jeanne Claude and Jonathan Henery, an exhibition curated by Josy Kraft.

FILMS (and Videos)

1969 *Wrapped Coast*. Blackwood Productions. 30 minutes.

1970 *Works in Progress*. Blackwood Productions. 30 minutes.

1972 *Christo's Valley Curtain*. Maysles Brothers and Ellen Giffard. 28 minutes. The film was nominated for the Academy Award in 1973.

1977 *Running Fence*. Maysles Brothers / Charlotte Zwerin. 58 minutes.

1978 *Wrapped Walk Ways*. Blackwood Productions. 25 minutes.

1985 *Islands*. Maysles Brothers / Charlotte Zwerin. 57 minutes.

1990 *Christo in Paris*. (The Pont Neuf Wrapped, 1975-85). David and Albert Maysles, Deborah Dickson, Susan Froemke. 58 minutes.

1995 *Christo and Jeanne-Claude, an overview of the oeuvre 1959-1995*. Blackwood Productions. 58 minutes.

1996 *Umbrellas*. An 81 minute film by Albert Maysles, Henry Corra and Graham Weinbren. The film won the Grand Prize and the People's Choice Award at the 1996 Montréal Film Festival.

1996 *Christo und Jeanne-Claude, "Dem Deutsche Volke", Verhüllter Reichstag 1971-95*. (Wrapped Reichstag). Wolfram and Jörg Daniel Hissen, EstWest. 98 minutes.

1998 *"Christo and Jeanne-Claude, Wrapped Trees"* Gebrüder Hissen, EstWest. 26 minutes.

Printed : De Muyter n.v., Deinze - Belgium

Published by Hugh Lauter Levin Associates, Inc.
www.HLLA.com
ISBN: 0-88363-003-6

Distributed by Publishers Group West